People
COUNTRY'S
Biggest Stars
2011

CONTENTS

32

50

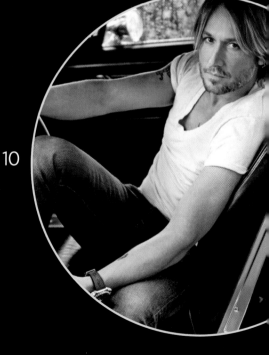

10

106

The Kings
OF THE ROAD

Platinum sounds and
sold-out arenas

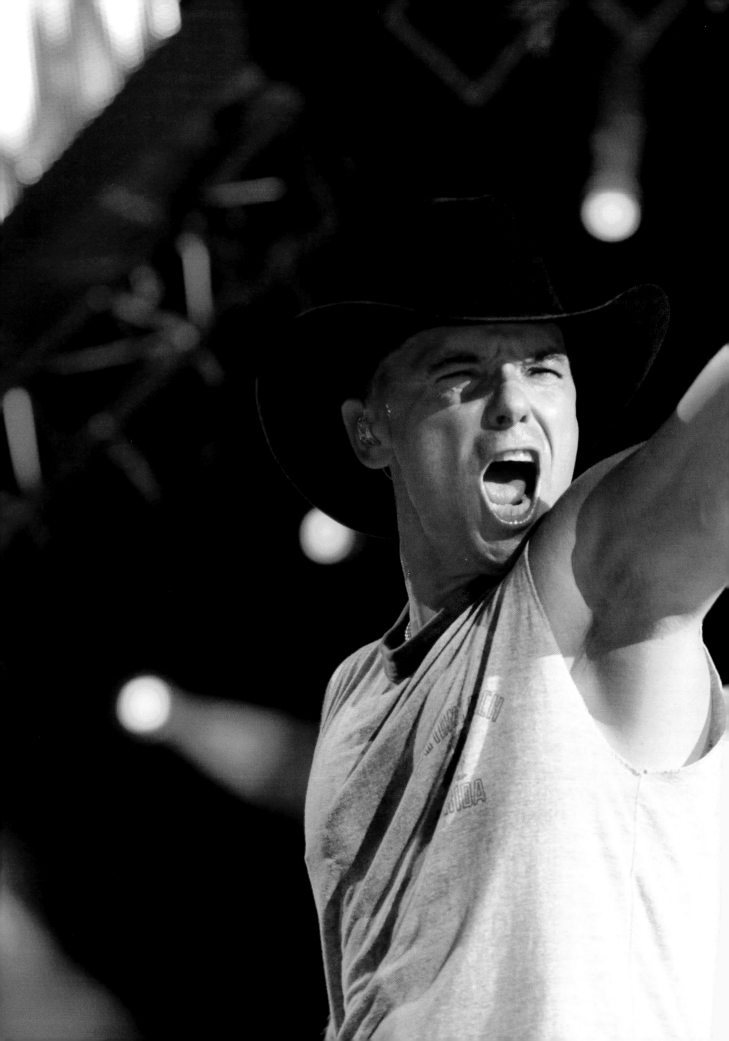

KENNY CHESNEY

SOLD MORE THAN
1 MILLION CONCERT TICKETS ON EACH
OF HIS LAST SEVEN TOURS

MORE THAN 30 MILLION ALBUMS SOLD	**$71.1 MILLION** TOTAL GROSS FOR HIS 2009 SUN CITY CARNIVAL TOUR	20 No. 1 COUNTRY SINGLES

He's been on the road for almost 18 years and set a record as country music's biggest North American ticket-seller of the past decade, yet Kenny Chesney shows no signs of slowing down. Even after taking a hiatus from touring in 2010 for some much-needed R&R, Chesney was back and bigger than ever on his high-octane Goin' Coastal stadium tour in 2011. "My favorite way to spend a Saturday night is onstage," says the singer, 43. "The emotion and the passion I get from the crowd, there's nothing like it."

The same could be said for Chesney's stamina. The four-time CMA and ACM Entertainer of the Year winner from rural Luttrell, Tenn., honed his skills as a performer in local restaurants and clubs while earning an advertising degree at East Tennessee State University. Moving to Nashville in 1991 "was scary and tough," he says. "I had a lot of dreams, but I didn't really know how to go about doing anything." Even though Chesney's first studio album, *In My Wildest Dreams*, was met with only mediocre success, his second effort, *All I Need to Know*, garnered him two Top 10 hits in 1995 and fueled his climb to superstardom, which now includes 20 No. 1 singles on Billboard's Hot Country Songs chart, nine platinum-selling albums and a concert film, *Kenny Chesney: Summer in 3D*, taken from his 2009 summer

tour. "You know that expression, 'You have to crawl before you can walk and walk before you can run?' That's where I started. I'm not an overnight sensation," he says. "I've been lucky in the music business, but I've worked very hard."

When he's not packing the stadiums full of fans, Chesney can be found playing just as hard in the Caribbean, where he owns a home on St. John., or cheering on his favorite sports teams. (In 2010, he even filmed two football documentaries for ESPN.) And even though his 2005 marriage to actress Renée Zellweger lasted only four months, he doesn't dismiss the idea of walking down the aisle again some day. "I'm not one of those people who wants to be in love for the sake of being in love," he says. "But I believe in it."

Chesney's fans trust that he'll continue to deliver the goods onstage as well—a show at Massachusetts's Gillette Stadium sold out in eight minutes. And the singer doesn't have it in himself to disappoint. "I'm going to keep reminding people through music that you've got to love life, and you've got to live it," Chesney has said. "I look at myself in the mirror and say that every single day."

> " Once you've got music in you, you can't hold it in forever. It's gotta come out "

THE MAKING OF A SUPERSTAR

ca. 1980 | Chesney didn't play until he got a guitar for Christmas in '87. "I never woke up and said, 'I want to be a country star,'" he says.

1994 | His first album, *In My Wildest Dreams,* didn't even make the charts.

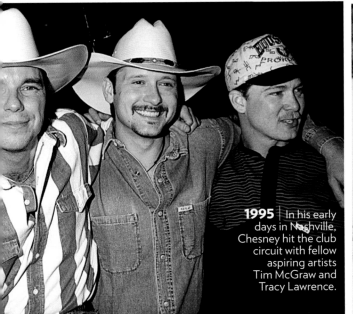

1995 | In his early days in Nashville, Chesney hit the club circuit with fellow aspiring artists Tim McGraw and Tracy Lawrence.

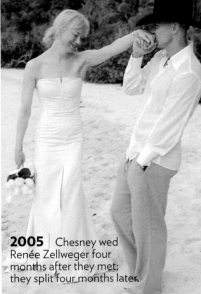

2005 | Chesney wed Renée Zellweger four months after they met; they split four months later.

2008 | With four CMA Entertainer of the Year awards, Chesney has tied the record held by Garth Brooks.

KEITH URBAN

HIS ESCAPE TOGETHER WORLD TOUR GROSSED $42.7 MILLION IN 2009

MORE THAN 12 MILLION ALBUMS SOLD	721,086 NUMBER OF TICKETS SOLD TO HIS ESCAPE TOGETHER TOUR	12 No. 1 COUNTRY SINGLES

He's shared a stage with Garth Brooks, Brad Paisley, Dolly Parton and John Mayer. But for Urban, his greatest collaboration to date might just be in the form of a toddler, his 3-year-old daughter Sunday Rose. "Sometimes when Sunny is singing in the car, if she's really locked into it, I'll be able to harmonize with her," says Urban, 43. "I have to do it quietly because if she hears me, she'll go to what I'm singing, but it's the most amazing feeling."

And Urban has plenty to be amazed about. Since his Nashville solo debut in 1999, the singer has become one of country's most bankable stars, selling more than 12 million albums and selling out stadiums around the world. With his talent for combining tender lyrics with rock-and-roll swagger and sizzling guitar licks, the four-time Grammy winner has also racked up armfuls of awards and 12 No. 1s on Billboard's Hot Country Songs chart, including "You'll Think of Me," "Better Life," "You Look Good in My Shirt" and 2009's "Somebody Like You," which Billboard named the country song of the decade.

Born in New Zealand and raised in Australia, Urban himself first delved into music by playing guitar at age 6, and he won several talent competitions in school. Being a musician "is all I've ever wanted to do," he says. "I don't know if it was all I was ever good at, but it's just what was the strongest, most natural path for me." After scoring four hit singles with his self-titled debut album in his homeland in 1991, Urban set up shop in Nashville the next

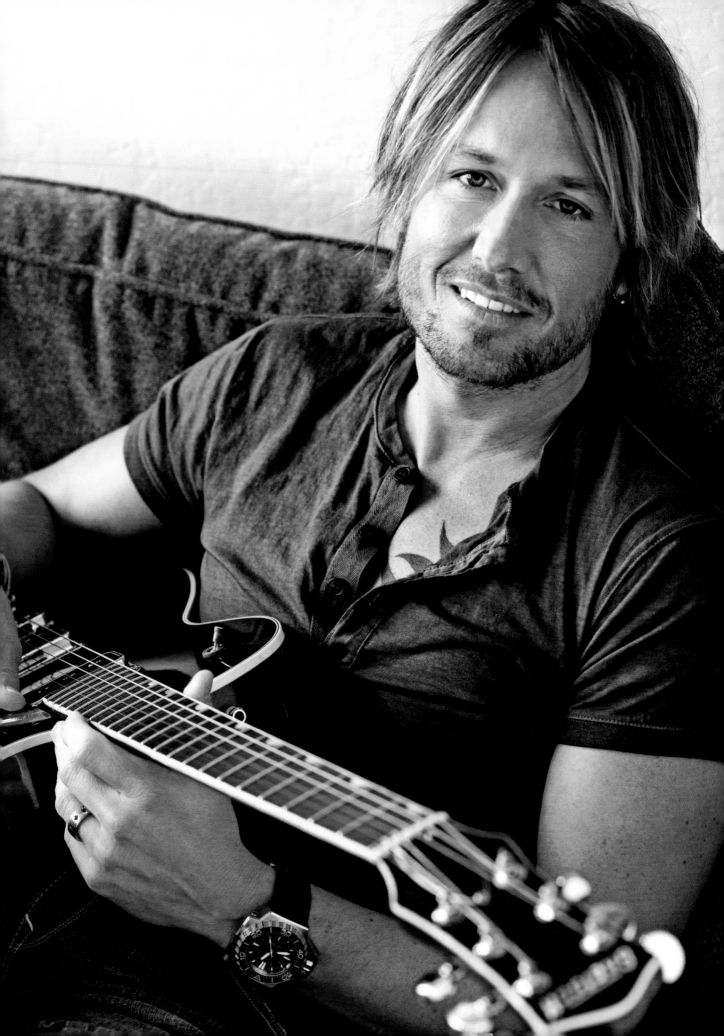

year. But while his musical skills quickly earned him respect as a go-to session guitarist, breaking out didn't come easily. "It wasn't like the success translated," he says. "I knew I had to start all over again in Nashville." Urban formed the country band The Ranch (its 1997 self-titled album met with modest success, charting just two singles) before striking out on his own with his now-platinum 1999 CD *Keith Urban*.

Urban's growing fame only intensified in June 2006 when he married Oscar-winning actress Nicole Kidman and then, four months later, just as he was about to promote his album, *Love, Pain & the Whole Crazy Thing,* voluntarily entered into a treatment facility for alcohol abuse. Kidman, who stood firmly by her new husband, "listened to her heart and did what she felt was the right thing to do," he says. "To see that kind of love in action, that's very moving and deeply inspiring and just makes me want to be a better man."

Urban has since channeled that love and devotion into his music, spawning countless songs about his life with Kidman and their daughters Sunday Rose and Faith Margaret (who was born via a surrogate in December 2010). "That's all the stuff that was in my heart," he says. "I put it in song form first, but if given the chance, I'll put it into action too. Because it's easy to say it, but I want to be able to show it."

Even on the road for his 2011 world tour, Urban's focus remained squarely on his priorities at home. "I've finally just found the right everything," he says. "The woman I'm supposed to be with and the family that I didn't even know was going to happen or not. I couldn't imagine life without them."

> "I've learned to really be grateful for the pain too because it tells me I'm in love"

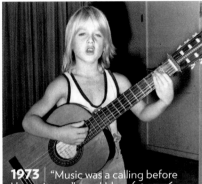

1973 | "Music was a calling before I knew it was," says Urban (at age 6, in Australia).

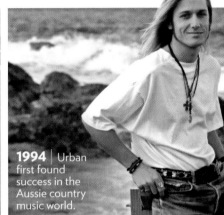

1994 | Urban first found success in the Aussie country music world.

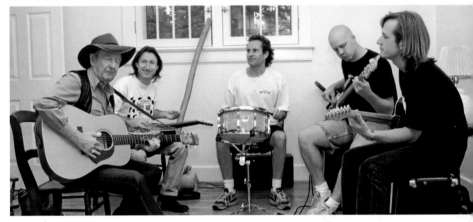

1998 | In Nashville, Urban got his start backing up artists like Alan Jackson and Brooks & Dunn. He made his Opry debut playing guitar for Australian country star Slim Dusty (left).

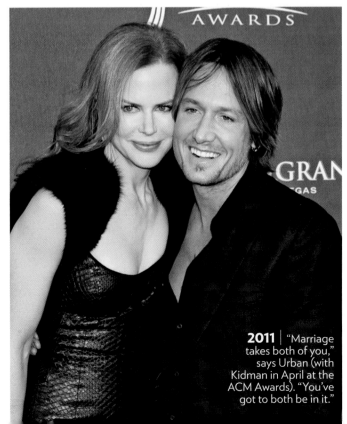

AWARDS

2011 | "Marriage takes both of you," says Urban (with Kidman in April at the ACM Awards). "You've got to both be in it."

13

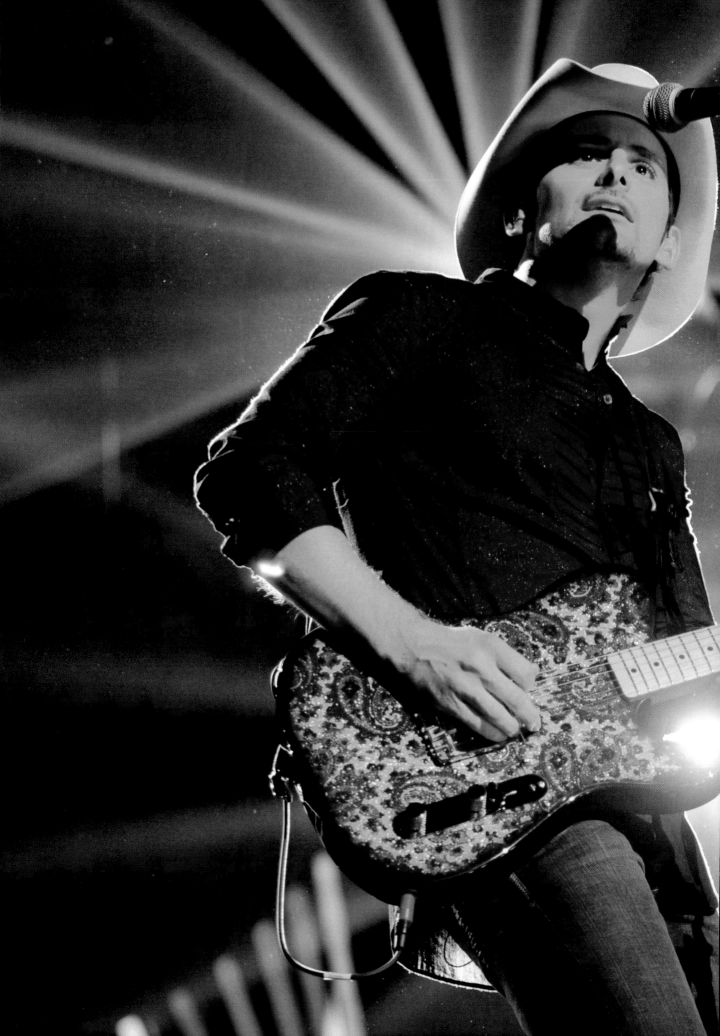

BRAD PAISLEY

HIS H20 WORLD TOUR SOLD MORE TICKETS THAN ANY OTHER COUNTRY TOUR IN 2010

MORE THAN 12 MILLION ALBUMS SOLD	**$40.7 million** TOTAL GROSS FOR HIS 2010 H20 TOUR	17 No. 1 COUNTRY SINGLES

In May 2010, just three weeks before Paisley launched his ambitious H20 world tour, his stage set, road gear and much of his guitar collection were wiped out. Nashville had been hit by an historic flood, but, true to form, Paisley still managed to find the humor in a bad situation. "Just know," he tweeted, "that as you watch us perform on the H20 tour, our entire stage and set has literally been under water. Now that's cred right there." Paisley and his crew "went through hell and back," he says, to make their opening date. Their first song? "Water."

It's that kind of hard work and easy humor—not to mention some serious guitar skills (he's considered by many to be country's best in the business)—that helped earn Paisley, 38, his first CMA Entertainer of the Year trophy in November of that year. Nominated five times previously for the honor, it was one of the only awards the singer hadn't won. To date, he's scooped up three Grammys and three CMA male vocalist honors and was named ACM top male vocalist for five consecutive years.

Raised in Glen Dale, W.Va., Paisley got his musical start at 8 when his maternal grandfather bought him a secondhand guitar and taught him to play. "We played on the back porch and anywhere the relatives wouldn't complain," he says. At 12, he was discovered by a radio programmer while performing at a Rotary Club lunch and became a regular on the national radio show *Jamboree USA*.

"It's a privilege
not to be taken lightly
to get to do this
for a living"

In 1999 he released his first album, which went platinum.

He's since sold more than 12 million albums and topped Billboard's Hot Country Songs chart 17 times, with songs both funny ("Ticks," "Online") and heartfelt ("The World," "Then"). But it wasn't until he met actress Kimberly Williams (he'd had a crush on her since seeing her in *Father of the Bride*) that his personal life matched his professional success. The couple married in 2003 and have two sons, Huck and Jasper.

Because he insists on being a hands-on dad at home, he tries to schedule tour dates in short bursts. "I'll go away for three or four days a week, but when I'm home I spend the whole day with them," he says.

On the road, Paisley has earned a reputation for both his pranks (his crew once filled tourmate Taylor Swift's bus with live crickets) and his attention to detail (he creates the big-screen computer animation sequences himself). "I love getting a chance to experience first-hand the effect a song has on somebody," he says of performing. "Nothing's more rewarding."

INSIDE BRAD'S WORLD

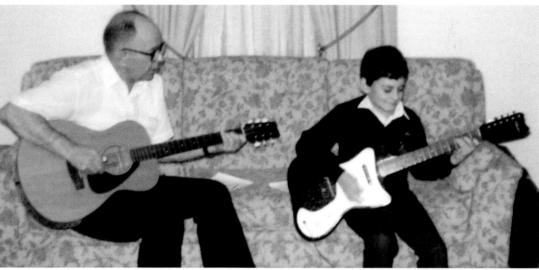

Paisley dedicated his CMA Entertainer of the Year win to his grandfather, who gave him his first guitar.

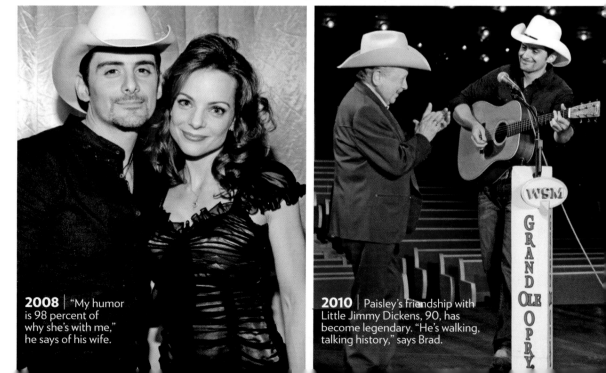

2008 | "My humor is 98 percent of why she's with me," he says of his wife.

2010 | Paisley's friendship with Little Jimmy Dickens, 90, has become legendary. "He's walking, talking history," says Brad.

TIM McGRAW

HIS 2010 SOUTHERN VOICE TOUR GROSSED $39.1 MILLION

MORE THAN 40 MILLION ALBUMS SOLD	**833,773** NUMBER OF TICKETS SOLD TO HIS 2010 SOUTHERN VOICE TOUR	24 No. 1 COUNTRY SINGLES

Just moments before the curtain rises on his latest tour stop, McGraw buzzes with energy. He's just back from a five-mile sprint with some of his bandmates and his pulse is still racing. "It is timed so I run straight into the dressing room, get ready and I'm still pumping when I hit the stage," he says. It's an entrance fit for a rock star—or, perhaps, a king. "My husband's like Elvis onstage; he truly is," says wife Faith Hill. "He's an amazing performer."

You'll get no argument from McGraw's fans. His Southern Voice tour was one of the most successful country tours of 2010, but with a résumé boasting 24 No. 1s on Billboard's Hot Country Songs chart, three Grammys, 14 ACMs and 11 CMAs—and critical acclaim for his ventures into acting in films like *Friday Night Lights* and *The Blind Side*—McGraw is accustomed to superlatives.

More than two decades after the Louisiana native left college to pursue his Nashville dreams, and 17 years after scoring his first Top 10 with "Indian Outlaw," the singer is still at the top of his game, thanks in no small part to healthy habits like his preshow run and giving up alcohol three years ago. It's a far cry from his bad boy days when he calmed stage fright by downing drinks: "I am sort of an unsure, self-conscious, shy person, and that's how I used to do it." McGraw, 45, says he changed his ways to set a good example for his

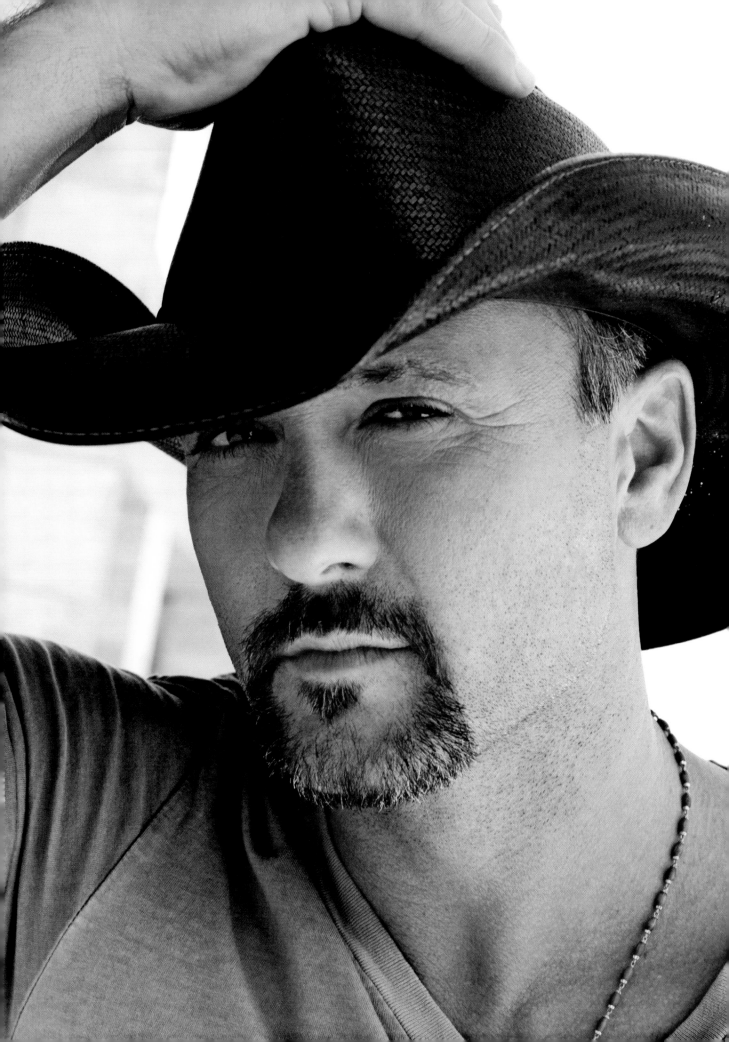

1983 | "Music wasn't my thing in school. I was wrapped up in sports."

> I love the charge you get out of a show. Your whole body starts tingling, from your fingertips to the top of your head

three daughters with Hill—Gracie, 14, Maggie, 12, and Audrey, 9. "I didn't want them to think that if you're a rock star, you drink before you go onstage."

In fact, whether they hit the road as a family, as they did in 2000 and 2006 on McGraw and Hill's wildly successful Soul2Soul tours, or whether McGraw is scheduling solo dates or a movie shoot, their girls are the couple's guiding force. "I fly in and out a lot, so I stay in contact with family mode, which is 95 percent of where I live," he says. And while he puts his all into his performances, it is not, he insists, about striking a balance. "Balance is the wrong word for us," he says. "That indicates equality, and there's no equality between career and family. Everything finds its place after family."

CHARACTER STUDY: TIM GOES HOLLYWOOD

FRIDAY NIGHT LIGHTS | 2004
McGraw surprised critics with his portrayal of an alcoholic father.

FLICKA | 2006
McGraw tested his riding skills as a rancher dad.

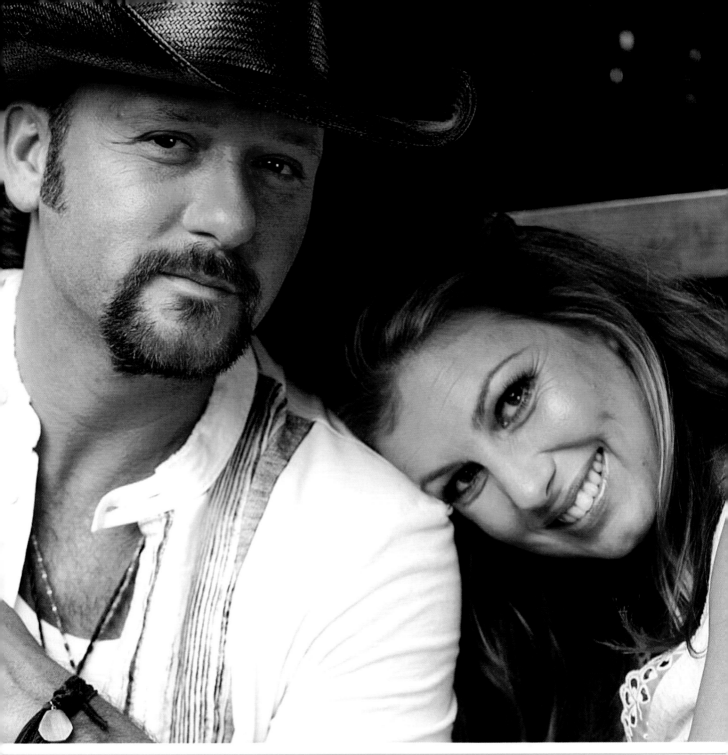

OUR
?HRISTMASES
?08
?as eating
?erything," he says
?he 25 lbs. he
?ined for the role.

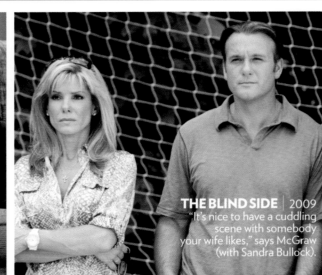

THE BLIND SIDE | 2009
"It's nice to have a cuddling
scene with somebody
your wife likes," says McGraw
(with Sandra Bullock).

COUNTRY STRONG | 2010
McGraw played manager-husband
to Gwyneth Paltrow's country star
but didn't sing a note.

TOBY KEITH

HIS 2010 AMERICAN RIDE TOUR GROSSED $25.5 MILLION

| MORE THAN 33 MILLION ALBUMS SOLD | 177,000 NUMBER OF SOLDIERS HE'S PLAYED TO OVER HIS NINE USO TOURS | 19 No. 1 COUNTRY SINGLES |

No one will ever accuse Keith of mincing words. When he finally won his first ACM awards—for male vocalist and album of the year—in 2001, he was more than happy to rub it in his critics' noses. "I've had my heart broke going seven years without winning," he said at the time. After the telecast "everybody who had ever done me right got hugged and kissed, and everybody who had done me wrong got the finger."

That kind of love-me-or-leave-me attitude may not have won Keith many friends in Nashville but it has certainly won him plenty of fans. Since he first hit the top of the charts with 1993's "Should've Been a Cowboy," (which went on to become the most played country song of the 1990s) Keith, 50, has sold more than 33 million albums and charted 19 No. 1 singles on Billboard's Hot Country Songs chart. He has also starred in two movies and landed himself at #51 on *Forbes* list of the richest celebrities thanks to a top-grossing tour and an ever-expanding business empire that includes his Show Dog-Universal record label and a chain of I Love This Bar & Grill restaurants. Not that Keith intends to trade performing for the executive suite for good. "The 65 shows or more I work a year are the easiest part," he says. "And I'm addicted to it."

Keith began his music career as a teen, when he taught himself to play guitar

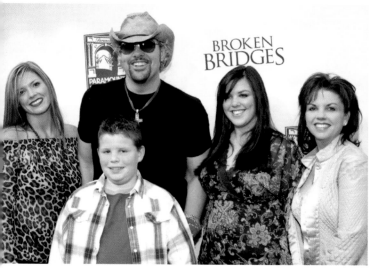

BROKEN BRIDGES

2006 | At the premiere of his movie *Broken Bridges* with (from left) daughters Shelley and Krystal, wife Tricia and son Stelen.

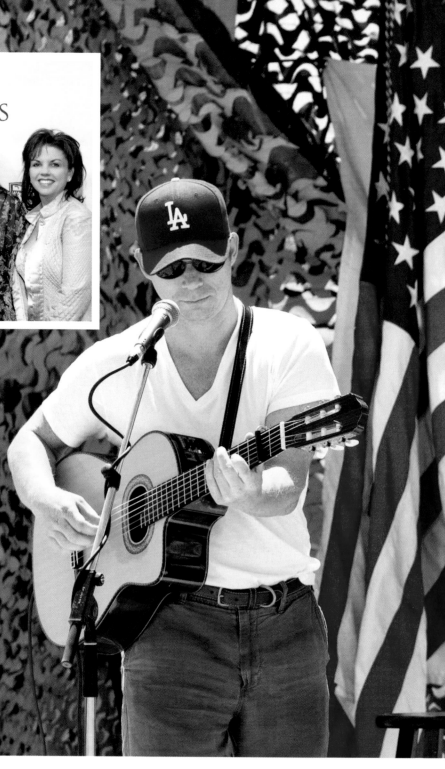

and began writing his own songs. "I wrote 200 to 300 songs, and then I wrote a good one," he said in 2001. While earning a living working the oil fields and playing semi-pro football, Keith played clubs around his native Moore, Okla., and set a goal for himself: "It was a prayer I prayed back when I was playing the bars and staying in the bad motels that if I couldn't be a [successful performer] before I was 30, maybe I could be a songwriter," he says. One month shy of that milestone birthday, he got the call that landed him his first record deal.

Now, almost 20 years later, Keith has met all his goals and then some—although he still bristles at what he sees as the politics of the music business. "If you've had the biggest year in ticket sales, album sales, radio play and then get shut out of an awards show because of agenda stuff, your fans don't understand," he said in 2010. It's one reason he chooses to live in Oklahoma instead of Nashville, with Tricia, 49, his wife of 27 years, and his son Stelen, 14. (The couple also has daughters Shelley, 30, and

Krystal, 25, now recording on her father's label.) "You get a thick skin early on in this business," he says. "And you learn what you are willing to put up with and what you aren't. The bottom line? You are your own guy."

He also resents the way he's been portrayed in some media, after his infamous 2003 "feud"

with the Dixie Chicks's Natalie Maines—she called his No. 1 hit "Courtesy of the Red, White and Blue (The Angry American)" "ignorant"; he parried that Maines criticizing his song was "like a softball player critiquing Barry Bonds's home runs." "Everything you say now is political," he says. "I don't see

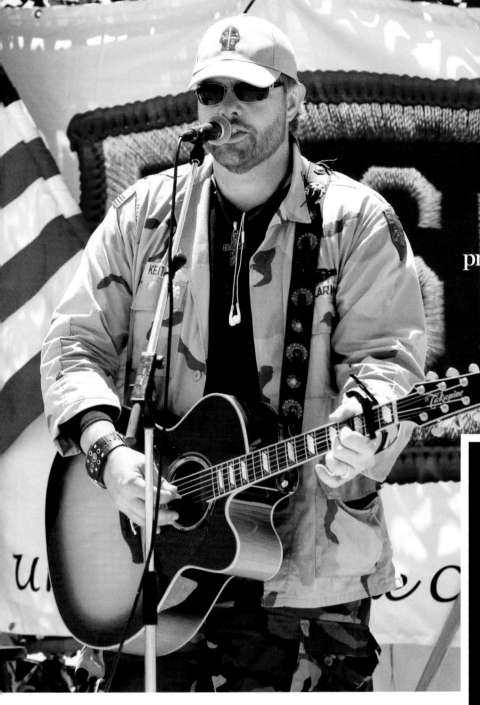

> " I don't have any problems being honest in songs. I love that "

ACTING IT OUT: TOBY'S MOVIE ROLES

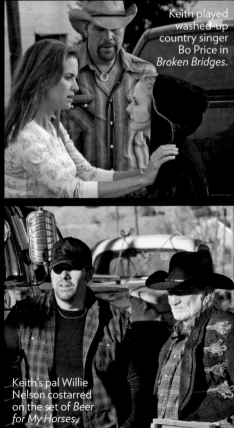

Keith played washed-up country singer Bo Price in *Broken Bridges*.

Keith's pal Willie Nelson costarred on the set of *Beer for My Horses*.

things right and left. I see things right and wrong."

Chief among those things he sees as "right" is his support for the troops. Keith credits his late father, H.K. Covel, who served in the Army during the Korean War, for instilling in him the importance of patriotism. Every year since 2002, he has done at least one USO tour to entertain troops.

"A lot of guys or girls give me their dog tags at shows," he says. "Or family members will say, 'We lost our son, and we'd like to give you a set of his dog tags to say thank you for supporting the troops.' I try to wear them as much as I can onstage as a memorial."

TAYLOR SWIFT

THE ONLY COUNTRY ARTIST TO SELL OUT ALL TOUR DATES IN 2010

MORE THAN 20 MILLION ALBUMS SOLD	**$34.2 million** THE TOTAL GROSS OF HER FEARLESS TOUR IN 2010	4 No. 1 COUNTRY SONGS

For someone who was the top-selling *and* most-played artist of 2010, and who fans voted the Academy of Country Music's Entertainer of the Year, Swift has a surprising perception of herself. "I've never felt popular," says the singer-songwriter. "Sometimes my mom will be talking to me, and she'll say, 'You know, you still think you're the girl no one talks to, don't you?'"

Not only do people want to talk to the Grammy winner now, they're also shelling out hard-earned cash to hear her sing. In fact, when tickets to Swift's Speak Now tour—98 shows in 17 countries—went on sale last fall, the first three concerts on the North American leg sold out in minutes. It's a feat some artists spend their entire careers trying to achieve; Swift was only 20 at the time. "I feel lucky," she says, "because I was raised to work for everything that you get and never be presumptuous about success."

Swift was just a tween when she embarked on her country career, going door-to-door on Nashville's Music Row looking for someone to sign her. "I would say, 'Hi, I'm Taylor. I'm 11. I want a record deal. Call me,'" she says. It helped that she was a talented songwriter, who drew inspiration from her own experiences (and those of her friends) to create catchy songs about crushes, exes and occasionally revenge. Love, she says, "is the one thing in life that is so unpredictable that I will never figure it out. So I write songs about it constantly." Already those

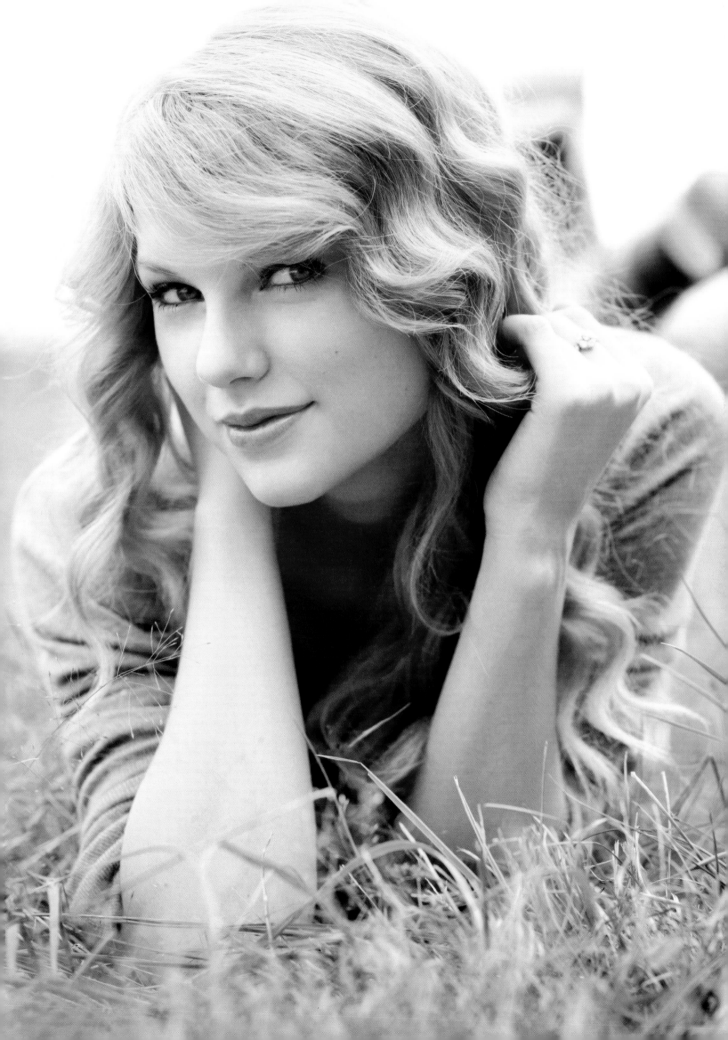

songs have scored her four No. 1 hits on Billboard's Hot Country Songs chart (including "Love Story" and "You Belong to Me") and, with 37 million career song downloads, made her the top-selling digital single artist in any genre. Swift is coy when it comes to discussing her personal life, but her romances with fellow stars including Taylor Lautner, John Mayer and Joe Jonas have become fodder for many of her tunes (see box)—and she makes no apologies for it. After three albums, she says, "I figure these people have had fair warning." Swift's busy career often leaves little time for love, but performing around the world has brought its own thrills. "I loved traveling to places where they speak different languages, and watching them mouth the words to my songs in English," says the singer, who dressed up as a geisha while touring in Japan. She adds, "I've gotten to hug people in dozens of countries."

In fact, even a trip to the grocery store can lead to an informal meet-and-greet. Yet the former outsider takes it all in stride. "Music has brought a lot of beautiful things into my life," says Swift, 21. "I never wanted to be the girl who gets everything she dreams about and starts complaining about it."

THE EVOLUTION OF A COUNTRY PRINCESS

1992 | Swift (at age 3) says she's been singing "for as long as I can remember."

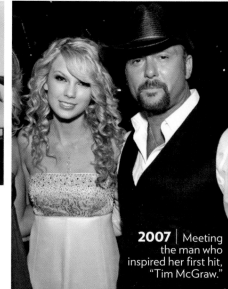

2007 | Meeting the man who inspired her first hit, "Tim McGraw."

> **I've seen and experienced places I never dreamed I'd get to**

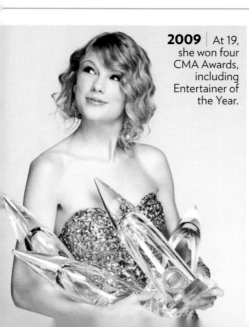

2009 | At 19, she won four CMA Awards, including Entertainer of the Year.

BET YOU THOUGHT THIS SONG WAS ABOUT YOU...

Swift wrote "Forever & Always" after Joe Jonas broke up with her in 2008. He's also thought to be the inspiration for "Last Kiss."

A fling with John Mayer may have inspired two songs: the wistful "The Story of Us," about an awards show run-in, and the wicked "Dear John."

Swift and Taylor Lautner broke up around the time of the titular month in "Back to December," an apology song.

The
BIG VOICES

Their powerful pipes
are the heart of country

CARRIE UNDERWOOD

When newly crowned *American Idol* champ Underwood arrived in Nashville in 2005, the town may not have pulled up the welcome mat, but it hardly rolled out the red carpet for the Checotah, Okla., singer. "A lot of people had one eye cocked because it was this big Hollywood talent show," recalls fellow Okie Vince Gill. "But I told her, 'Don't worry about how you got the door open, just get in.' And once the door opened, her talent was undeniable." These days, red carpet treatment is everyday stuff for Underwood, who is *Idol*'s top earner with 16 million albums sold and $66 million in tour revenue. She's already won five Grammys, was inducted into the Grand Ole Opry and made history as the only female artist to win ACM Entertainer of the Year twice— "a magical moment," she says.

"Carrie is the best singer in any format of music," says Brad Paisley. "I'm floored by her."

But before her rapid rise to country stardom, she was just a college kid raised on her parents' cattle ranch who had never even been on a plane. A journalism major who hoped to work at a local news station, she thought maybe she'd get to sing a little "at church on Sunday or karaoke on Wednesday nights." Then came *Idol*.

Her debut album, *Some Hearts,* released in 2005, topped the chart (and went seven times platinum) and produced three No. 1's, including the crossover smashes "Before He Cheats" and "Jesus Take the Wheel." The two albums that followed also went multiplatinum and at the age of 28, Underwood already has 10 No. 1 hits.

"The possibility of Carrie's longevity is through the roof," Gill says. "There are fine singers and there are gifted, great singers, and she's one of those. Her vocal skills are off the hook."

Meanwhile, the Oklahoma farm girl who "probably

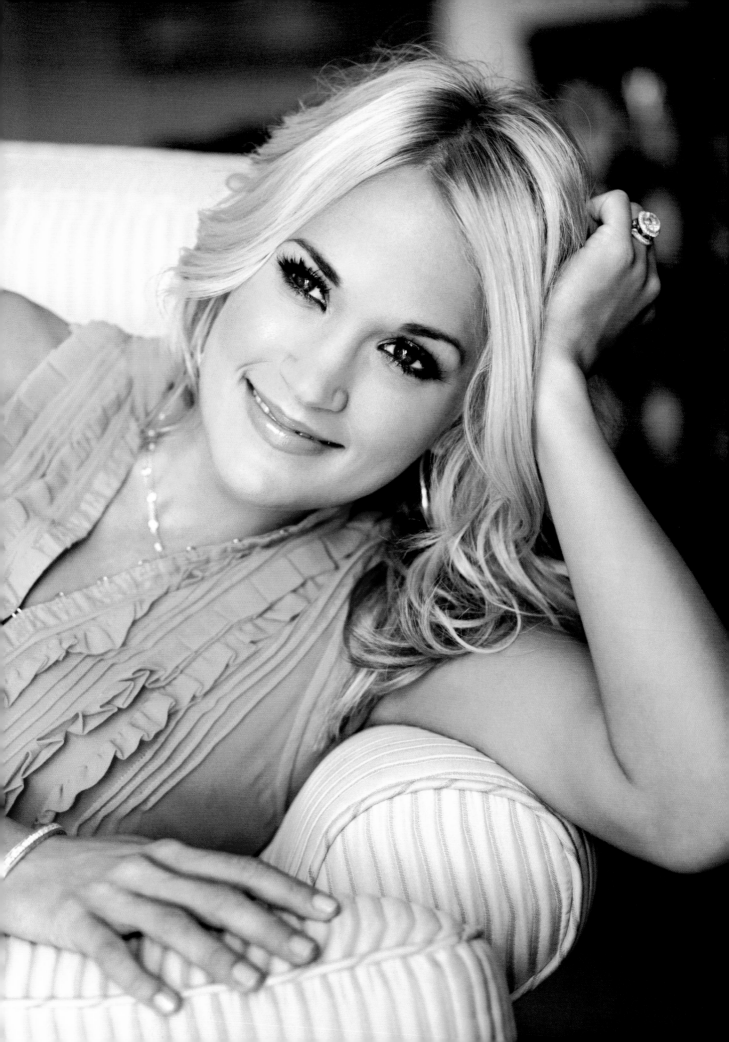

"
The legacy
I want to leave
is not just musical.
I want to be
a good example
"

owned one pair of high heels my whole life" became a fashion icon. "In the beginning it was: 'I don't want them to say mean things about me,'" she says of her wardrobe choices. "But after a while you get bored, and I like to play."

Public curiosity grew too about her personal life. After a few brief relationships with high-profile men (including Dallas Cowboys quarterback Tony Romo and actor Chace Crawford), Underwood met her match in Canadian hockey player Mike Fisher,

and the two carried out an 18-month, long-distance courtship. "He's the missing piece of the puzzle," the singer says. "He makes me a better person." The couple married in July 2010. The next year Fisher was traded to the Nashville Predators, and the newlyweds set up home in Music City.

It is, Carrie says, right where she belongs. "Take the stage and the lights and all the stuff away, even if I'm in my shower, washing my hair, singing just makes me happy," she says. "To me nothing's better."

THE MAKING OF A COUNTRY IDOL

1987 | "I was spoiled, but I never did anything wrong!" says Carrie (at 4 on her parents' ranch) of her childhood.

2004 | Being on *American Idol* "was like star boot camp," she says.

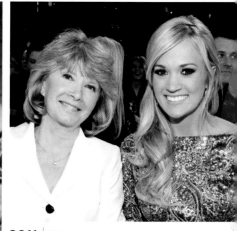

2011 | "It's amazing to think that's the little kid I raised, and she's so poised up there," says her mom, Carole.

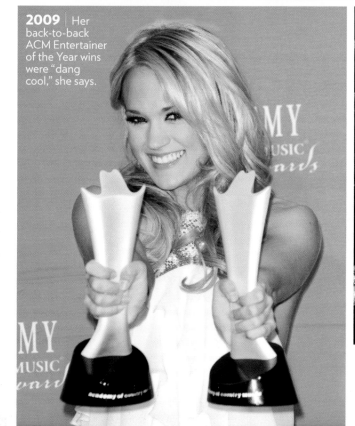

2009 | Her back-to-back ACM Entertainer of the Year wins were "dang cool," she says.

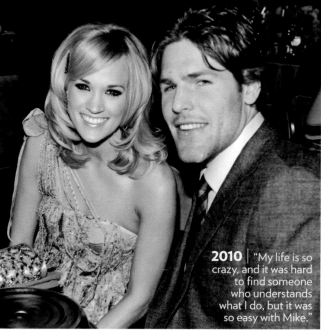

2010 | "My life is so crazy, and it was hard to find someone who understands what I do, but it was so easy with Mike."

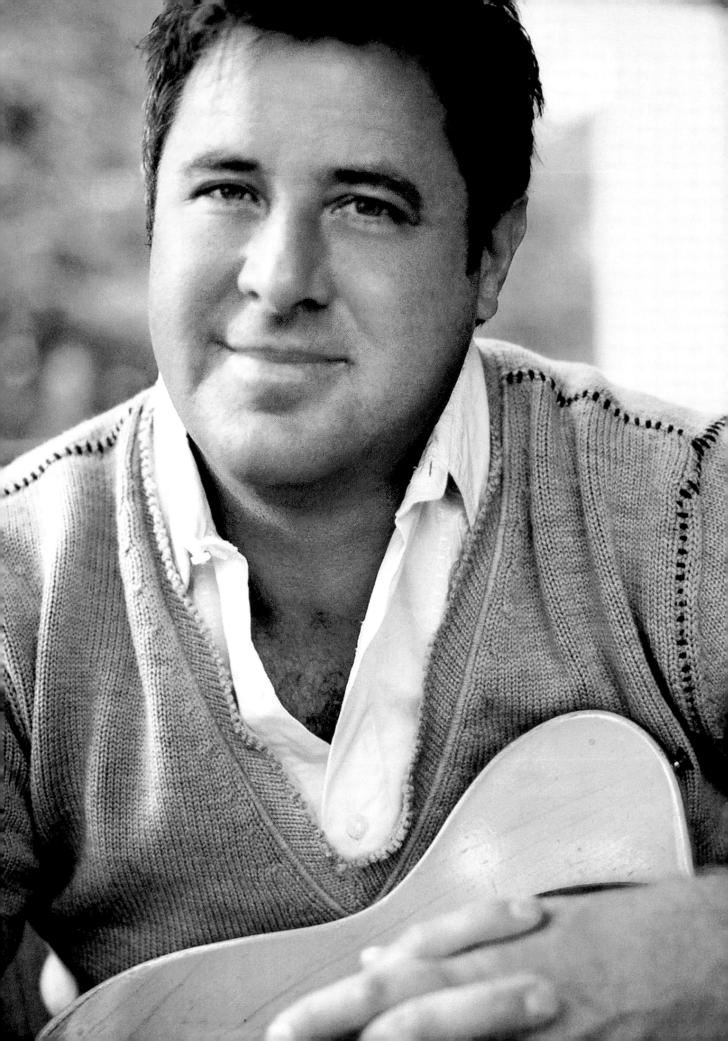

VINCE GILL

t's one of Gill's standard self-deprecating lines to poke fun at his famously high-pitched tone as less than masculine. But then again, as he's pointed out, "I live in a pretty nice house because I sing like a woman." In fact, that high lonesome sound has earned the singer 20 Grammys, 18 CMAs and the distinction of being one of the most in-demand collaborators in Nashville.

A gifted athlete from Norman, Okla., who played in bluegrass bands in high school, he saw chart success in the '80s as part of country-rock band Pure Prairie League (that's his smooth tenor singing lead on the 1980 hit "Let Me Love You Tonight"). Gill had dreamed of pop stardom in the singer-songwriter vein of Jackson Browne but soon realized country music was a better fit. When he broke through as a country artist in 1990 with "When I Call Your Name," he stood out in a sea of hat acts for his Stetson-free style ("I don't cowboy up too hard," he explained at the time) and his dark-haired good looks (though, when remarked upon, he'd insist, "I'm not a heartthrob type. I've got a little bit of Gomer in me."). But what really set him apart was that tender tone and his scorching guitar talent, which influenced Brad Paisley and Keith Urban and prompted Dire Straits frontman Mark Knopfler—who once asked Gill to join his band—to say he played "like a god."

Despite his own impressive body of work, which includes a string of Top 10 hits and 26 million in album sales, Gill, 54, says he gets as much joy from his turns as a session player and back-up vocalist for a host of other Nashville stars. "I never really thought I'd be an artist and a singer," he says. "I always liked being part of the process. I don't think you have to be front and center to matter. Getting to sing with George Jones or Loretta Lynn, they're my heroes. The list goes on and on of things I never dreamed I'd get to do. I feel pretty grateful most of the time."

MARTINA McBRIDE

S he may have eight platinum albums under her belt, but for this country star, the small stuff matters just as much. As the daughter of a Kansas wheat farmer, "We didn't have a lot, so you find happiness in little things," she says. "A comfy bed, a beautiful meal, a car that runs, the feel of my 3-year-old's hand in mine."

Called the "Celine Dion of Country Music" for her impressive soprano range, McBride, 44, got her start at the age of 6, singing in her family's country-rock band. "Singing was my identity," she says. So much so that she dropped out of junior college after one semester for a spot in a band called the Penetrators. "I was so naive," she jokes. "I thought, 'That sounds like a good name!'" The band covered Pat Benatar tunes, adds McBride, and "made no money—but I wouldn't trade the experience for anything."

She'd surely say the same about the next band she joined, which rented warehouse rehearsal space from a sound engineer named John McBride—whom she'd go on to marry in 1988. In 1991, John took a job with Garth Brooks's tour crew, and Martina went too, selling Garth T-shirts at the souvenir table. A year later, she was opening for Brooks onstage and racking up the first of a string of hits including "Wild Angels," "Independence Day" and "This One's for the Girls."

Now the mother of three daughters, McBride admits she has her hands full juggling motherhood with touring and songwriting (her latest single, "Teenage Daughters," was inspired by the challenges of raising Delaney, 16, Emma, 13, and Ava, 6). But she wouldn't have it any other way. "They keep me grounded," she says. "It would be easy to get caught up [in the trappings of stardom]. They give me something else to think about and take care of. It's not all about me all the time."

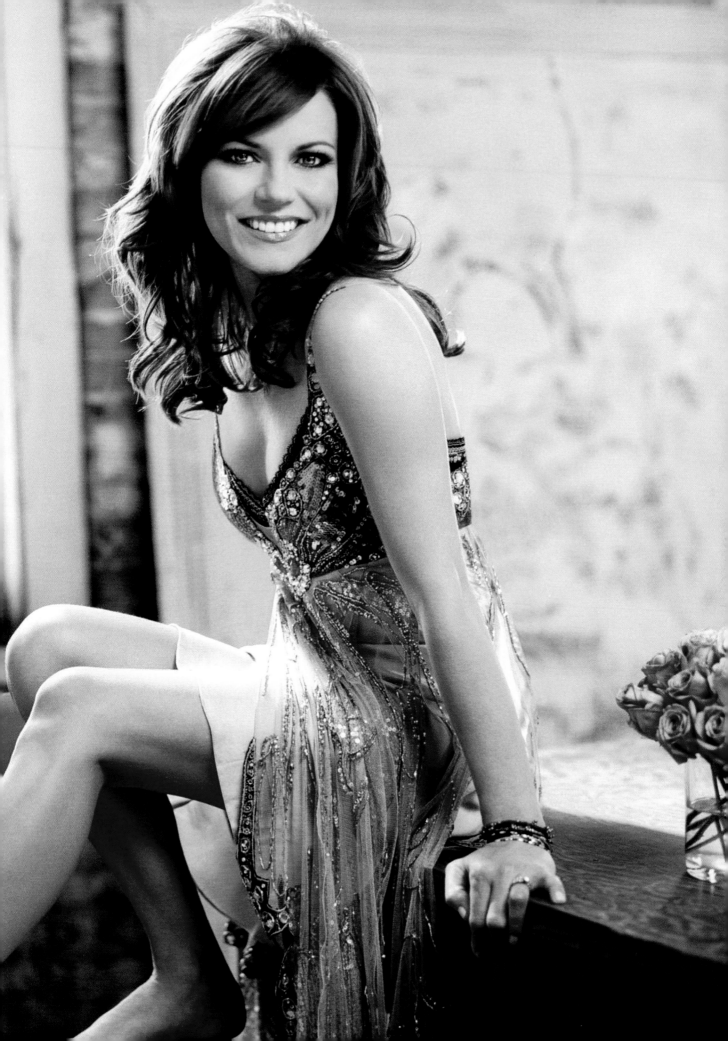

THE FLATTS
(from left)
Jay DeMarcus,
Gary LeVox and
Joe Don Rooney.

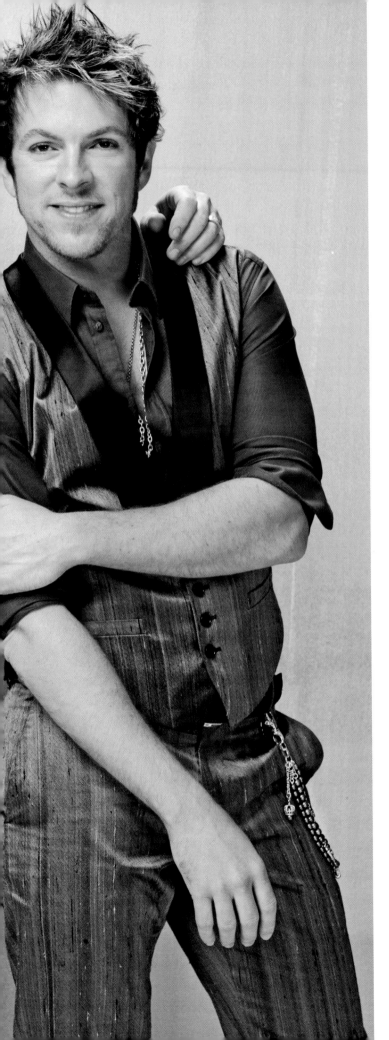

RASCAL FLATTS

If it wasn't for Jay DeMarcus, Rascal Flatts may have never come together. In the late '90s, he convinced his cousin Gary LeVox to leave his job working with the developmentally disabled in Columbus, Ohio, and join him in Nashville to pursue a music career. "We started writing together," says DeMarcus, 40, "and sang every chance we got."

Then, one night at a gig at Nashville's Fiddle and Steel Guitar Bar in 1999, they met guitar player Joe Don Rooney. After a stellar performance as a trio, they decided to make it official. It was a good call: Since their first CD debuted in 2000, they've sold more than 20 million albums in the U.S., notched multiple No. 1 hits—including "What Hurts the Most," "Why Wait" and the iconic "Bless the Broken Road"—and headlined some of the biggest tours of the past decade. "As a kid, you only dream about being able to sell out arenas and stadiums," says LeVox, 40, who provides the band's signature soaring vocals. "The feeling is awesome."

The trio, who are all married and have five kids among them, also maintain a genuine friendship off the road. "We're easygoing guys who get in our sweats, sit on the couch, watch football, eat pizza and drink beer," says Rooney, 35. "We're not just business partners, we are good friends."

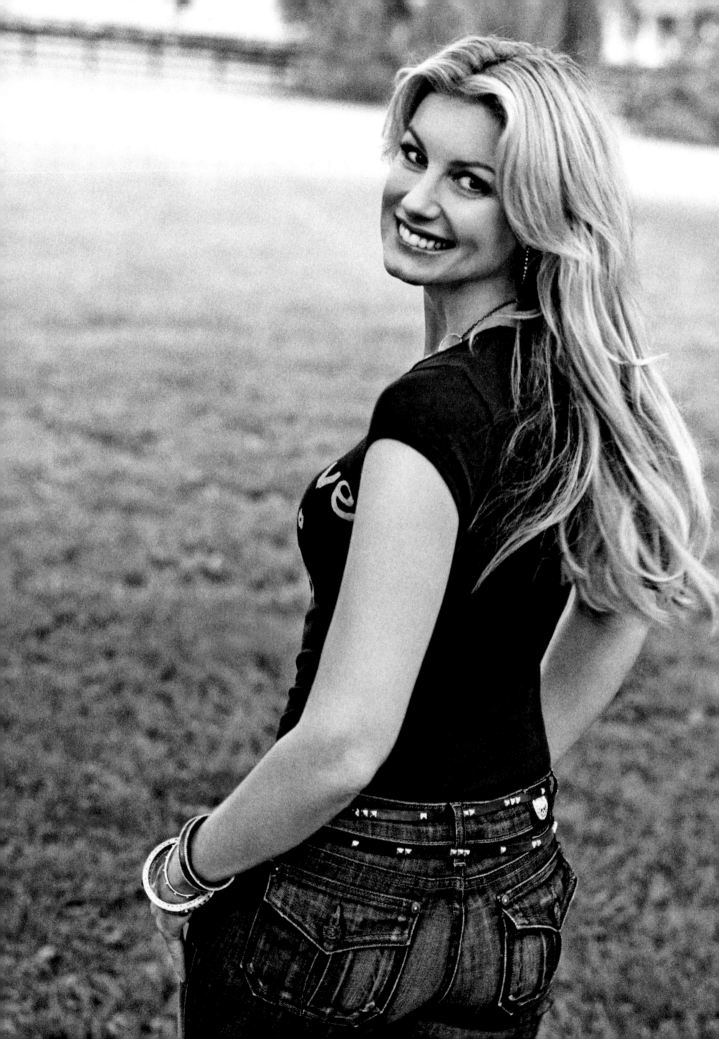

FAITH HILL

As a lanky schoolgirl performing in her church choir, Audrey Faith Perry "could bring the roof down when she sang a cappella," recalls a childhood friend. The singer (who changed her name after moving to Nashville in 1987) can now pack arenas rather than church pews, but Hill and her powerhouse pipes still rock the house—to the tune of five Grammys, 9 No. 1 hits and more than $30 million in album sales.

Adopted as an infant and raised by a factory worker father and bank teller mother in tiny Star, Miss., (pop: 500), Hill found inspiration in gospel music and in the soulful voices of Aretha Franklin and Tina Turner. "It doesn't have to be about God, but anything spiritual and uplifting is my favorite music to sing," she says. "It brings me back to where it all started." Her start in Nashville, however, is the stuff of country music lore. After failing to win a slot as one of Reba McEntire's back-up vocalists (the singer who got the job was killed in a 1991 plane crash, along with several of Reba's bandmates) she worked as a secretary for a music publisher until her 1993 breakout single, "Wild One." Three years later she met Tim McGraw on the Spontaneous Combustion tour and sparks flew. They married that year. After the birth of their first two daughters (a third followed in 2001), the couple were launched into superstardom with their 2000 Soul2Soul tour and her massive crossover hits, "This Kiss" and "Breathe."

Hill, 43, may downplay her talent ("I'm not the kind of performer my husband is. He has such charisma. I'm really just a singer"), but McGraw's happy to brag: "People sometimes overlook how good she is because they're looking at how good she looks. But she's one of the best soul singers around."

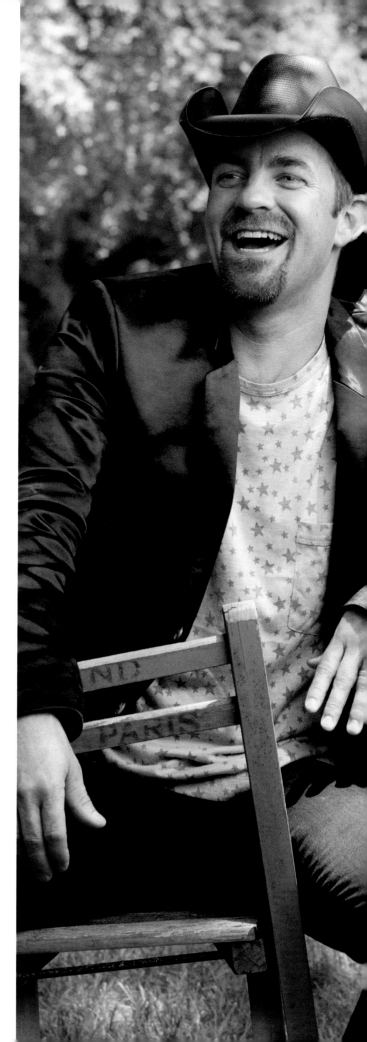

SUGARLAND

The fact that yoga mats are sold alongside the T-shirts and hats at Sugarland concerts is a telltale sign that Kristian Bush and Jennifer Nettles are not your typical country duo. With influences that include rock, gospel, R&B and even reggae, the Grammy-winning pair have found success—and fans—thanks to their genre-busting sound and Nettles's big voice. "I don't know how many times at meet-and-greets we get people who come up and say, 'I don't like country music, but I like what you do,'" Nettles has said. "We say, 'You are who we write records for, my friend. Come on over.'" Or as Bush put it, "Jennifer and I are the doormen for country music."

Georgia native Nettles and Tennessee-bred Bush (who plays guitar) met on the Atlanta music scene in 2003. Sugarland, which originally included Kristen Hall, hit it big the following year with their multiplatinum debut, *Twice the Speed of Life*. (Combined with their next three studio albums, they have racked up more than $8 million in record sales and five No. 1 singles.) "We care about what we do, and we want our fans to have a good time," said Nettles, 36. The pair have been enjoying themselves as well. Nettles recorded with Bon Jovi and James Taylor, and after meeting Paul McCartney, Bush, 41, admitted, "It's still shock that there's a Beatle who knows who we are." There's no telling what the future holds. Said Bush: "We dream really big."

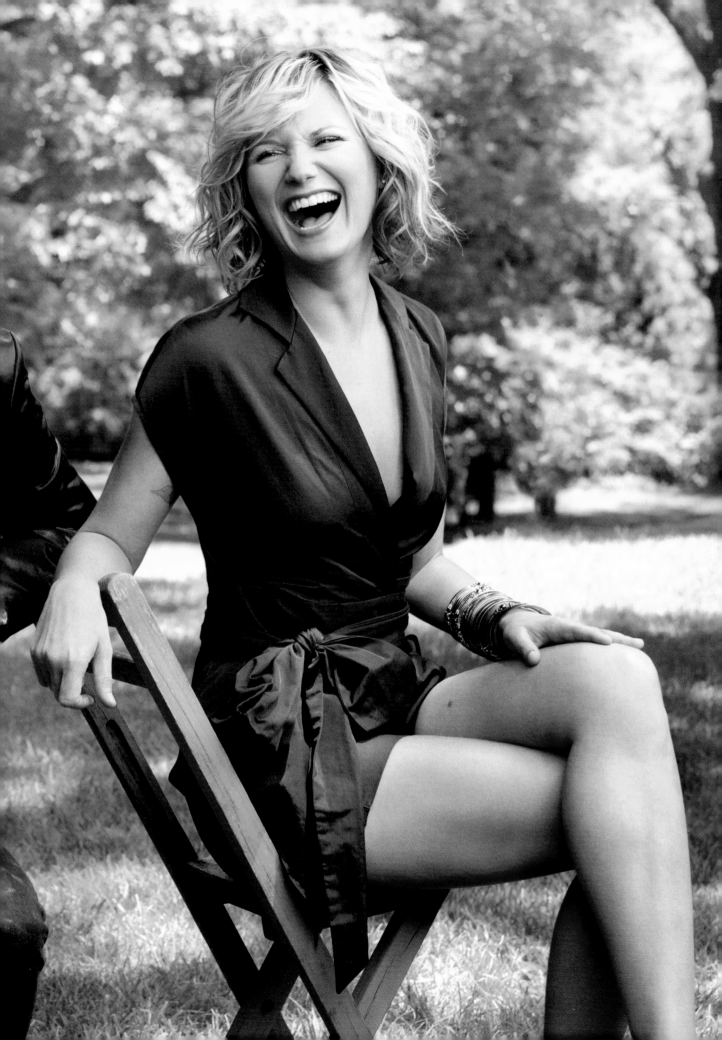

JOSH TURNER

Take it from his wife—after eight years of marriage, Turner can still work some magic with that rich baritone. "I swoon every time," says Jennifer of her husband's crooning. "I'm the luckiest woman on earth because I get to hear him sing so much."

The Hannah, S.C., native with the booming voice and boyish grin earned early comparisons to Randy Travis and Johnny Cash ("I never got offended by that—those were guys I looked up to, so I figured I was doing something right"). But with hits like his faith-driven 2003 single "Long Black Train" and the 2006 sexy charmer "Your Man," Turner, 33, made his own mark as a traditionalist with a twist. "I'm definitely an old soul," he says. "My music's got that down-home, backwoods, rural feel, but I'm always trying to make it sound fresh."

As a kid, "music just called my name," and he made his singing debut in church as a preschooler with an ode to Noah called "Arky, Arky." At 17, his granddaddy handed him his mother's old guitar. "He said, 'You need to learn to play chords along with the songs you're singing,'" Turner recalls. "He believed in me and a light went on—'I can write songs!' I could get things out that were in my heart."

It helped win a heart as well: Turner met Jennifer at Belmont University, and they married in 2003. His "biggest cheerleader," she sings and plays piano in his band and, along with their three boys, hits the road with him on tour. "We're always loading and unloading a bus," he says. "But we get to see the world together."

Their Life Is Like
A COUNTRY SONG

Hard times and heartbreak
only made them stronger

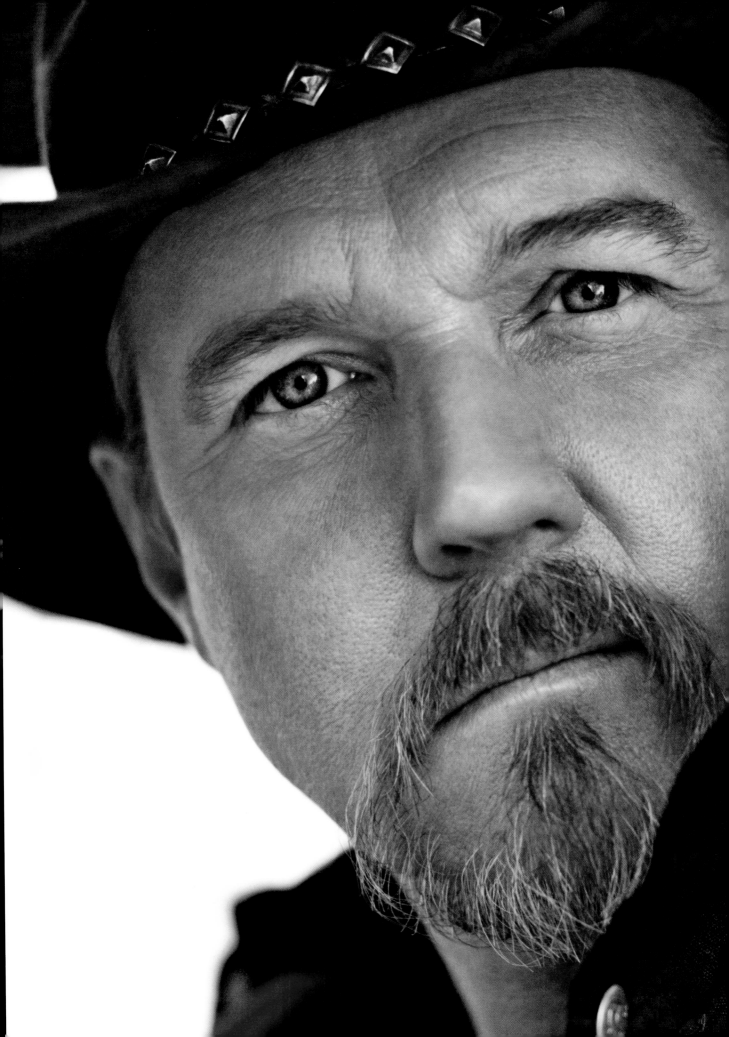

"I FORGAVE MY SECOND WIFE FOR SHOOTING ME
because I refuse to believe that she was actually trying to kill me"

TRACE ADKINS

He survived a near-fatal car wreck in high school, lost his baby brother in a car crash a few years later, almost lost his legs when he was run over by a bulldozer, chopped off his nose in a car accident and pinky finger while working construction (both were sewn back on!), rode out a hurricane atop an oil rig in the Gulf of Mexico and spent time in jail for drunk driving.

But it wasn't until one day in February 1994 that Adkins truly came face-to-face with his own mortality. Then married to his second wife, Julie Curtis, and trying to make a living as a songwriter, Adkins had spent the day at their home outside Nashville, "drinking beer all day [and] happily working away in the yard," he writes in his 2007 book *Trace Adkins: A Personal Stand.* "As far as I was concerned, no harm, no foul. I wasn't bothering anybody."

But when Curtis got home from work and found him drunk, again, all hell broke loose. She tried to throw him out, and when Adkins refused to leave, he found himself staring down the barrel of a .38 pistol. "Then I did the stupidest thing I'd ever done in my life," writes the Sarepta, La., native. "I turned into Captain Redneck. I decided I was going to disarm the lady." Reaching out toward his wife, Adkins, who stands at a towering 6'6", shouted, "Give me that goddamn gun before I take it away from you and beat your brains out with it." Curtis pulled the trigger and the bullet "went through both my lungs and both ventricles of my heart," he says.

During his second open-heart surgery to repair the damage, he remembers thinking, "This is it, Trace. Happy trails, hoss." But the pain and uncertainty of recovery had a silver lining: They brought him closer to then-friend Rhonda Forlaw. "There I was, shot like a dog. Yet she came to the hospital room and brought me a little basket with purple African violets in it," recalls Adkins. "I know it sounds funny, but that simple act of human kindness really helped me pull through."

> It's the best thing in life to have the people
> you love the most around you. That's a good day

And just as suddenly Adkins's luck began to change. Declining to press charges against Curtis ("It would be crazy to pretend that we weren't both to blame for what happened," he says), he instead filed for divorce and began dating Forlaw, 47, a former publicity manager at a record label. One day

while he was picking her up at the Nashville airport, she introduced him to the then-president of Capitol Records, Scott Hendricks, who happened to be on her flight. That weekend Hendricks checked out Adkins's show at a Nashville bar and immediately offered him a record deal.

Adkins, 49, who has been sober for nine years now, went on to rack up two platinum albums, a slew of awards (including the Academy of Country Music's Best New Male Artist in 1997) and hits like "(This Ain't) No Thinkin' Thing," "Ladies Love Country Boys" and the dance hall staple "Honky Tonk

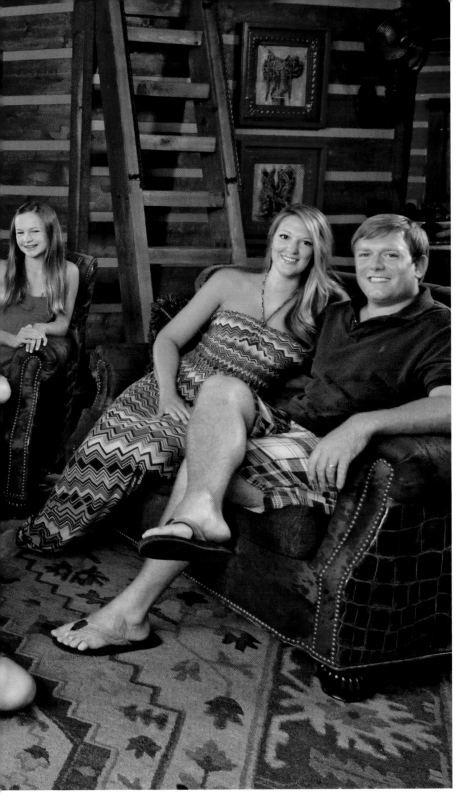

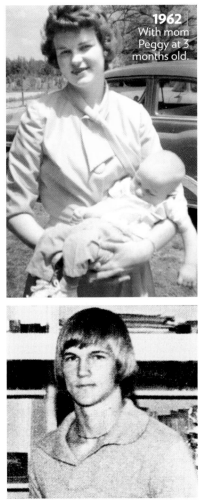

1962 With mom Peggy at 3 months old.

1979 | As a junior at Sarepta High School, the year of his near-fatal car wreck.

Badonkadonk." "I'm finally realizing a dream that I've had all of my adult life: to do what I love to do for a living," he says. "I'm going around the country singing, so I'm living out my dream just as loud as I can do it."

But while the career success is sweet, what really matters is his home life, says Adkins. He proposed to Forlaw on the stage of the Grand Ole Opry in 1996. The pair have now been happily married for 14 years and have three daughters together, in addition to Adkins's two daughters from his first marriage. "I'm most grateful for all my family," he says. "That's all I can ask for anymore."

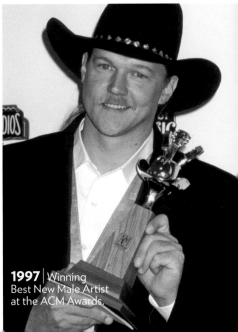

1997 | Winning Best New Male Artist at the ACM Awards.

"I WAS READY TO DIE—
to go to bed forever and never wake up
"

SHANIA TWAIN

For Twain, life's drama began even before she was born. While her mother was giving birth, there were complications, and Eilleen Edwards (as she was known before she began calling herself Shania—an Ojibwa word meaning "on my way"—and took her stepfather's last name) emerged blue from a lack of oxygen and was presumed stillborn. "Looking back," the singer wrote in her 2011 memoir, *From This Moment On*, "sometimes I can't help but think to myself, *So*, that's *what happened to me*. Ha! It explains a lot."

But getting through her first minutes in the world was just the beginning of her childhood struggles. Growing up in Canada, Twain and her siblings witnessed domestic violence at the hands of her stepfather, often went hungry and even spent one summer living in a homeless shelter. Her aspirations to become a singer and songwriter helped her get through the tough times, but that dream nearly ended at 22, when her parents died and she had to move home to take care of her younger siblings. Still, Twain found meaning in the dark times. "I believe deeply that everything happens for a reason," she wrote. "We need the bad to appreciate the good, and vice versa."

She took a job performing in a revue close to home, and eventually her luck changed. She landed a record deal, moved

to Nashville, and fell in love with music producer Robert "Mutt" Lange. With Lange's guidance, she launched a crossover career that won her five Grammys, seven No. 1 singles and the bestselling country album of all time, 1997's *Come On Over*. The pair married in 1993 and had a son, but even though they lived in a castle in La Tour-de-Peilz, Switzerland, the romance was no fairy tale: In 2008 Lange asked for a divorce; the next day Twain found out he was allegedly having an affair with her best friend. "I really didn't ever want to love again," she says.

But in what she calls a "beautifully twisted" turn of events, she ended up falling for—and marrying—the other woman's ex-husband, Frédéric Thiébaud. "My closest friends and family say they haven't seen me this free-spirited and happy in years," she says. "And it's definitely true." Now, a reflective Twain, 45, has no regrets. "I am actually grateful for what I've gone through," she wrote, "and wouldn't change a thing— although I admit I wouldn't want to live it over again, either. Once was enough."

SHANIA TWAIN'S UPS AND DOWNS

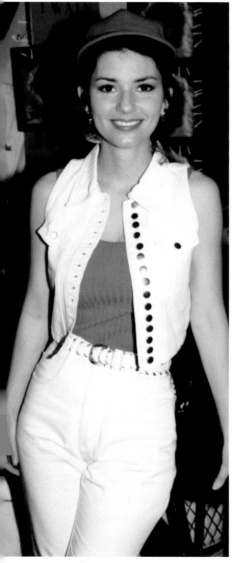

1995 | Twain (at Fan Fair in Nashville): "I was in the middle of the transition period between the before and after of fame."

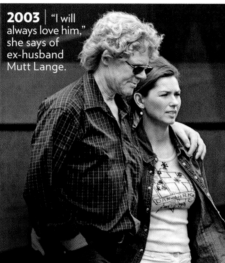

2003 | "I will always love him," she says of ex-husband Mutt Lange.

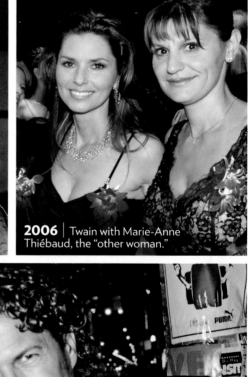

2006 | Twain with Marie-Anne Thiébaud, the "other woman."

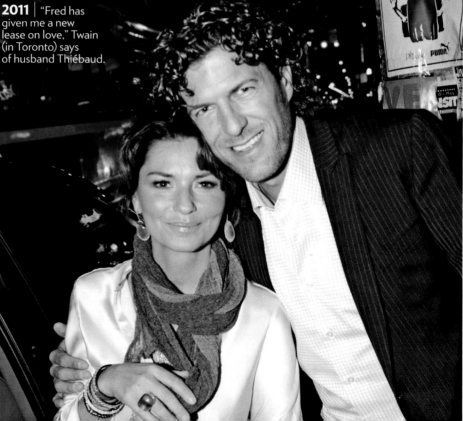

2011 | "Fred has given me a new lease on love," Twain (in Toronto) says of husband Thiébaud.

> "More than ever I'm putting my feelings into the songs I'm writing"

KELLIE PICKLER

She was just 2 when her mother left town. Her father battled drug addiction and bounced in and out of jail for assault and theft, leaving Kellie to be raised by her grandparents Faye and Clyde Pickler Sr. Then Kellie was left devastated again when Faye, who had always encouraged her to sing, died of lung cancer when Kellie was only 15. "I grew up fast," says the singer, 25. "But since I was a little girl, I've dreamed of living it big."

So Pickler traded a $2.50-an-hour waitressing job at a Sonic drive-in for the *American Idol* stage in 2006, where viewers fell in love with her daffy jokes and honey-dipped drawl. After reuniting with her father—he was released from prison the week after she was voted off *Idol* in sixth place—Pickler moved to Nashville and turned to songwriting as therapy. "I don't think grieving is just for someone who passed away. It's for everything you lose," she says. "You can cry for yourself for a little bit. But then you've got to get over it."

Although she remains estranged from her mother and continues to work on her relationship with her dad, Pickler has channeled her childhood heartbreak into hit singles like "I Wonder." And she scored her first Top 10 hit with "Best Days of Your Life," which she cowrote with pal Taylor Swift. Now working on her third album, she admits she is struggling with an unusual challenge: Married to songwriter Kyle Jacobs since Jan. 1, she says, "It's a lot harder to write sad songs when you're happy!" Looking at her wedding photos, Pickler marvels at her journey. "I can't believe that's the same little girl from Albemarle, N.C., who never thought she was going to get married and didn't believe in love," says the singer. "I'm in the happiest place I've ever been."

> ## "I'D NEVER SEEN MY MOM AND DAD
> in the same room except in the courthouse.
> Never seen a relationship the way it was
> supposed to be until now"

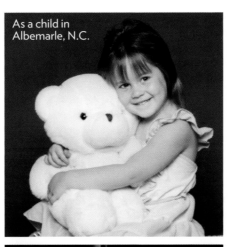

As a child in Albemarle, N.C.

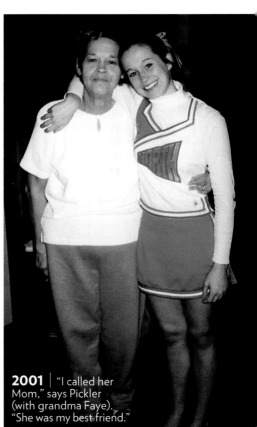

2001 | "I called her Mom," says Pickler (with grandma Faye). "She was my best friend."

2006 | "I've always loved my dad," says the singer (with dad Clyde "Bo" Pickler at *Idol*).

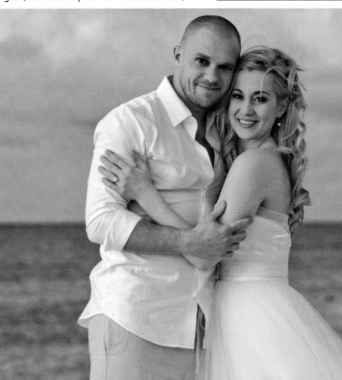

2011 | "I'm living my dream," says the newlywed (with husband Kyle Jacobs).

Before they were STARS

TRACE ADKINS
Sophomore Year 1978
Sarepta High School
Sarepta, La.

GARTH BROOKS
Senior Year 1980
Yukon High School
Yukon, Okla.

KIX BROOKS
Senior Year 1973
Sewanee Military Academy
Sewanee, Tenn.

ZAC BROWN
Freshman Year 1993
South Forsyth High School
Cumming, Ga.

KENNY CHESNEY
Senior Year 1986
Gibbs High School
Corryton, Tenn.

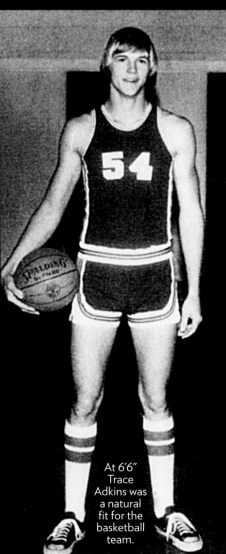

At 6'6" Trace Adkins was a natural fit for the basketball team.

Kenny Chesney, a wide receiver, spent two years playing for his school's team, the Gibbs Eagles.

BILLY CURRINGTON
Senior Year 1992
Effingham High School
Springfield, Ga.

SARA EVANS
Senior Year 1989
New Franklin High School
New Franklin, Mo.

VINCE GILL
Junior Year 1974
Northwest Classen High
School, Oklahoma City

DAVE HAYWOOD
Senior Year 2000
Lakeside High School
Evans, Ga.

FAITH HILL
Senior Year 1986
McLaurin Attendance
Center, Florence, Miss.

Homecoming
Queen
Faith Hill.

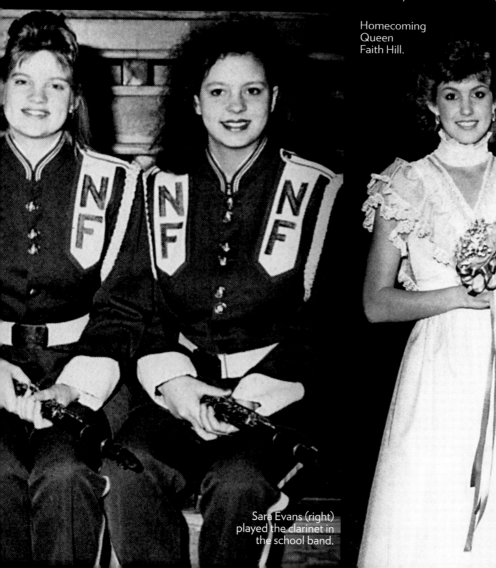

Sara Evans (right)
played the clarinet in
the school band.

Before they were STARS

ALAN JACKSON
Senior Year 1976
Newnan High School
Newnan, Ga.

TOBY KEITH
Senior Year 1979
Moore High School
Moore, Okla.

CHARLES KELLEY
Senior Year 2000
Lakeside High School
Evans, Ga.

MIRANDA LAMBERT
Senior Year 2002
Lindale High School
Lindale, Texas

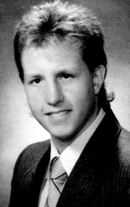

GARY LeVOX
Senior Year 1988
Olentangy High School
Lewis Center, Ohio

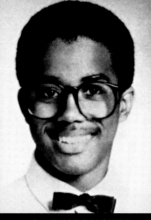

DARIUS RUCKER
Junior Year 1983
Middleton High School
Charleston, S.C.

BLAKE SHELTON
Senior Year 1994
Ada High School
Ada, Okla.

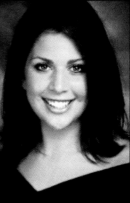

HILLARY SCOTT
Senior Year 2004
Donelson Christian
Academy, Nashville

GEORGE STRAIT
Senior Year 1970
Pearsall High School
Pearsall, Texas

TAYLOR SWIFT
Freshman Year 2005
Hendersonville High
Hendersonville, Tenn.

Tim McGraw won a landscaping trophy
from Future Farmers of America in 1983.

Martina McBride played the piano for the Girls'
Chorus at Sharon High School in 1984.

Theatre Geek?
Chris Young
was in the
school play.

MARTINA McBRIDE
Junior Year 1983
Sharon High School
Sharon, Kansas

TIM McGRAW
Junior Year 1984
Start High School
Start, La.

JENNIFER NETTLES
Junior Year 1992
Coffee High School
Douglas, Ga.

BRAD PAISLEY
Junior Year 1990
John Marshall High
School, Glen Dale, W.Va.

KELLIE PICKLER
Senior Year 2004
North Stanley High School
New London, N.C.

or a Family Living class in high school,
ary LeVox played the part of the groom.

SHANIA TWAIN
Senior Year 1983
Timmins High School
Timmins, Ont.

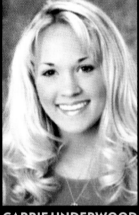

CARRIE UNDERWOOD
Senior Year 2001
Checotah High School
Checotah, Okla.

KEITH URBAN
10th Grade 1982
Caboolture State High

CHRIS YOUNG
Senior Year 2003
Oakland High School

Alan Jackson escorted
future wife Denise

The MODERN LEGENDS

They've rocked the charts
for 20 years or more

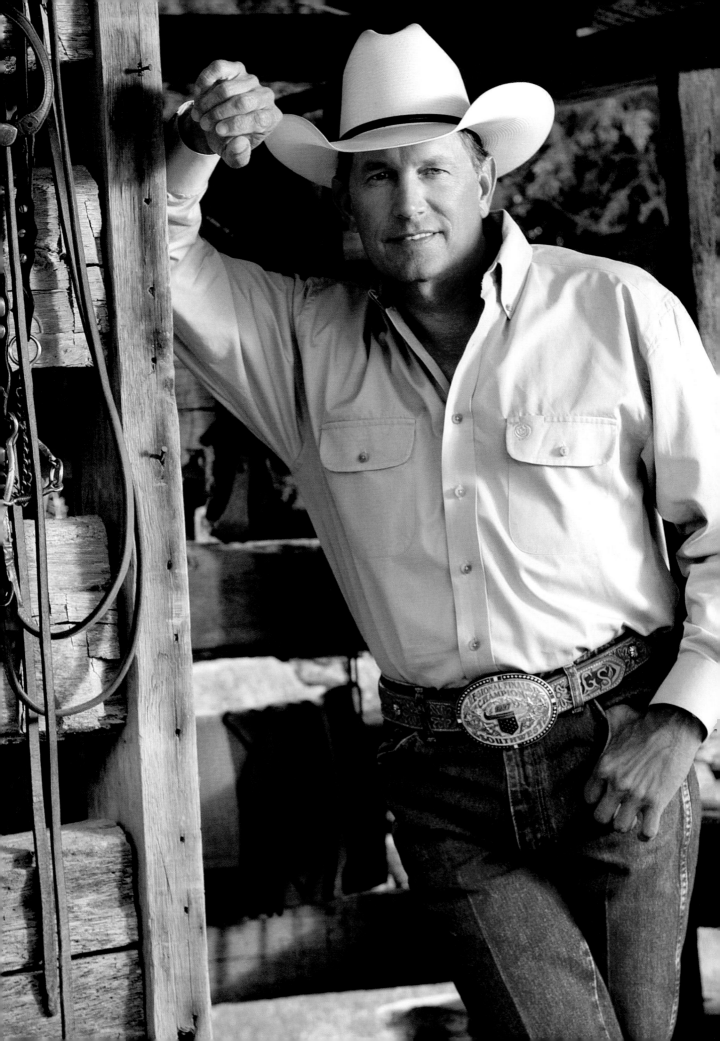

GEORGE STRAIT

ountry without King George seems almost unimaginable. But long before he became music royalty, Strait nearly hung up his hat. After five years playing Texas honky-tonks and making disappointing trips to Nashville, the then 28-year-old Army vet, fresh from college with a degree in agriculture and education, was ready to take a job at a metal fence post manufacturer. "I didn't think I was ever going to get anywhere in the music business, and I began to have doubts about my abilities," Strait said in 1985. "It was time to think of other things."

That's when his wife stepped in. "George was

moping around the house so much I couldn't stand it," says Norma, who's been married to Strait for 40 years. "I wanted him to give it one more try." The last shot turned out to be a bull's-eye, and in 1981, his two-steppin' debut single "Unwound" helped steer the Nashville Sound back to twin fiddles and pedal steel. "I guess I was in the right place at the right time," Strait says of his pioneering success.

Modesty becomes the 59-year-old soft-spoken cowboy, who has racked up more No. 1 singles than any other artist—44 and counting—and sold more than 68 million albums. "There's nobody in this industry

> " If you start messing around
> with changing yourself, you'll end
> up screwing up "

recording as long as George and still kicking our ass," says Keith Urban. "He's as pure as they come."

Growing up on a ranch in Pearsall, Texas, Strait learned early to rope, ride and play guitar. He enlisted in the Army in 1971 and honed his musical style (influenced by Merle Haggard, Hank Williams and Bob Wills) singing in a band while stationed on a base in Hawaii. It was pure country, then and now. "He hasn't had to change with the times," says fellow Texan Jack Ingram. "He is the times."

His style—Resistol hat, pressed Wranglers and a ranch shirt—has been as steady as his hits. "He doesn't have a wardrobe stylist or any of that ridiculous stuff," says pal Lee Ann Womack. "He's a man's man and doesn't get caught up in all the hype." Inducted into the Country Music Hall of Fame in 2006, he was recognized as ACM Artist of the Decade in 2009. "This is like a farewell deal, but I ain't ready to go yet," he quipped at the time. And thank goodness for that.

STRAIT THROUGH THE YEARS

1992 | Strait made his acting debut in *Pure Country,* as a disillusioned country star. Box office was tepid, but the soundtrack became a bestseller.

1981 | Friends joke about Strait's ever youthful appearance. "I love him and hate him because he looks so good," Garth Brooks quipped in 2009. "He looks the same as he did 30 years ago."

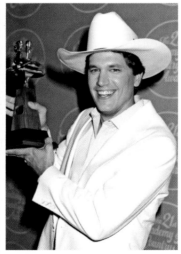

1991 | George and Norma with son George Jr. (known as Bubba). Their daughter, Jenifer, was killed in a car accident at age 13 in 1986.

1986 | "It's important for a country star to be able to sing," Strait said. "Anything else, like looks, is pretty secondary."

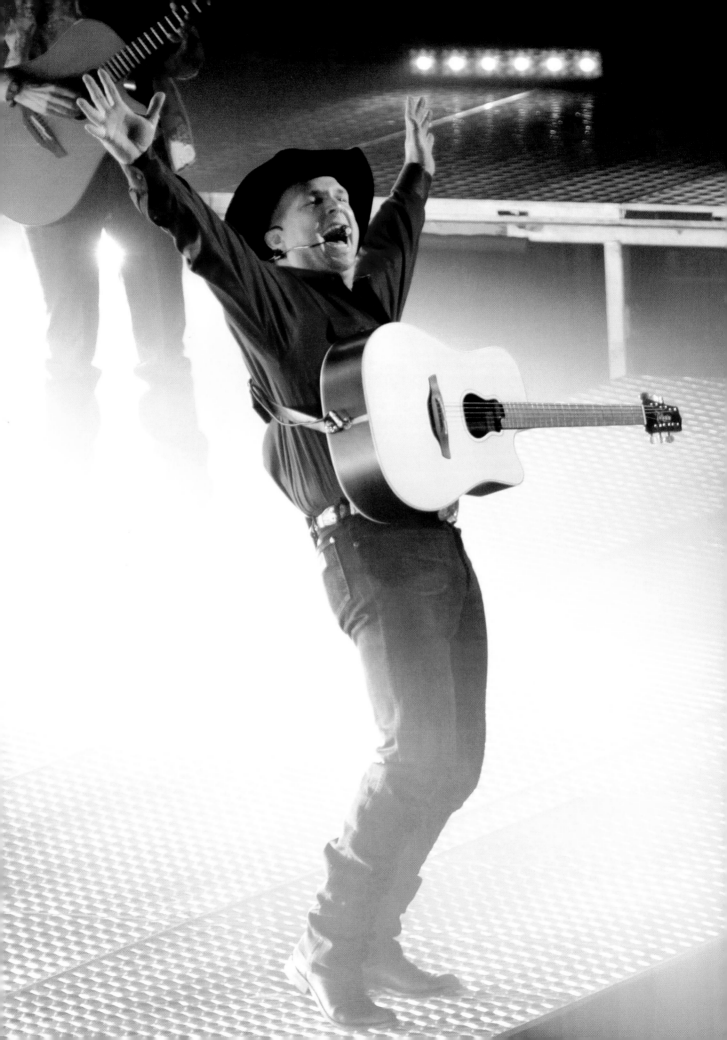

GARTH BROOKS

There was a time when Brooks dreamed of gold—medals, not records. The burly Oklahoma State undergrad hurled javelins 200 ft. and bench- pressed 300-plus lbs., but when he failed to make the Big Eight Conference finals in the sport in his senior year, "a coach came by and said, 'Well, now you can get on with what matters in life,'" Brooks recalled to PEOPLE in 1991. "I wondered, 'What the hell could that be?'"

As Brooks—and much of the world—would soon learn, big things were in store for the Yukon, Okla.-bred youngest child of a petroleum draftsman and a singer mother who was reared on the tunes of George Jones and Merle Haggard. Today Brooks, 49, boasts the most successful country career in history—and one of the most successful music careers *ever,* having sold a whopping 123 million albums and counting, making him the top-selling solo artist in *any* genre in history. And yet with all the 10-gallon success has also come personal conflict: between career and family, between fans and privacy, between Garth the Okie country boy and Garth the Nashville superstar. "When I read about me," he once said, "it's like a guy from outer space."

His music, though, has always been thoroughly down-to-earth. From his first No. 1 single, the heartbreaker

"If Tomorrow Never Comes," to the blue-collar anthem turned karaoke classic "Friends in Low Places," the neo-traditionalist country king has long found inspiration in life's everyday ups and downs. "I've always described myself as no more than the newsman at 6 o'clock, just put to music," he said in 1991. "All I'm doing is just reporting real life, and real life is sad and tense . . . and sometimes funnier than hell."

His own personal life has taken a series of dramatic turns, beginning with his 1986 marriage to college sweetheart Sandy, with whom he has three daughters: Taylor, August and Allie. The couple's rocky union ended in 2001, not long after Brooks announced his retirement. He spent the next four years almost entirely out of the spotlight, and in 2005 he married fellow country star Trisha Yearwood, 46. Still maintaining a low profile—he hasn't released an album of original new material since 2001—the master crowd-pleaser has returned to performing, with a recurring gig at Las Vegas's Wynn Hotel and occasional stadium shows for charity. But although he's no longer on the fast track, his legacy remains. "[Fans see me] as a real person, as the guy next door," he said in '91, "and as evidence that the American dream is very much alive, that you can go from a man that holds only a dream to one that feels like he holds everything."

> "There's a million things you can say that need to be said . . . things people have to be reminded of"

GARTH'S EXCELLENT RIDE

Even as a boy, Brooks loved to perform.

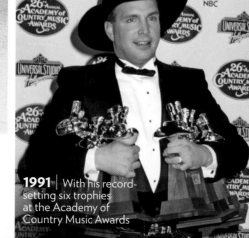

1991 | With his record-setting six trophies at the Academy of Country Music Awards

1992 | TIME credited him with bringing country to the masses.

...the life of chris gaines

1999 | Brooks made a quirky foray into rock as soul-patched alter ego Chris Gaines.

06 | Brooks has called Yearwood "best friend"; she told PEOPLE she was "wled over" by his onstage proposal in '05.

2009 | Brooks performed at President Obama's inaugural celebration in Washington, D.C.

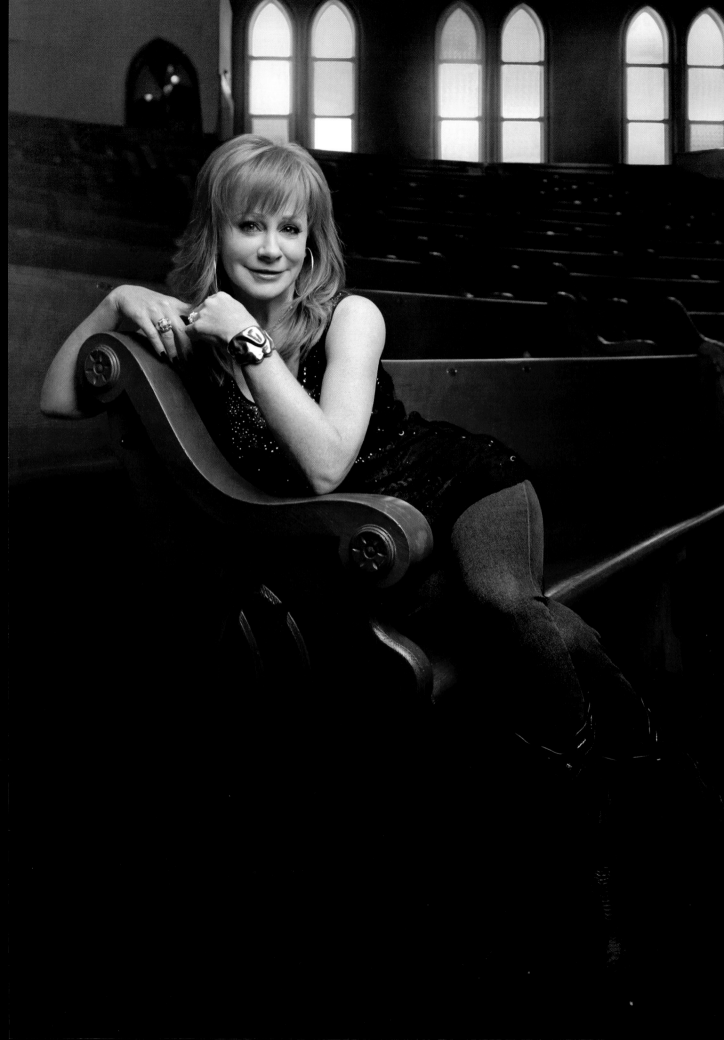

REBA McENTIRE

Growing up on a working cattle ranch in Chockie, Okla., McEntire came by her work ethic early. "My parents taught us responsibility," says the third of four children born to ranchers Clark and Jackie McEntire. "Once my sister Alice came in so late, Daddy was already up cooking breakfast. He waited until she got sound asleep and then woke her up, told her he needed help with the cattle that day, and he worked her butt off."

More than four decades later those lessons have paid off. Reba, who dropped her surname in 2010, is the reigning queen of country music, having sold more than 55 million albums and racked up 24 No. 1 hits including "Whoever's in New England," "Little Rock" and "Consider Me Gone." She has pushed Nashville's boundaries by covering songs from artists like Beyoncé, Aretha Franklin and Kelly Clarkson. And at 56, she more than holds her own on the concert stage against artists who weren't even born when she put our her first album in 1977. "I love to look for songs, and my formula for finding songs hasn't changed," she says. "I learn from everybody I watch. I don't focus on being fearful. I just go outside the barriers and try things."

> "I'm pretty much the same offstage as I am on. What you see is what you get"

In fact, from her first Oklahoma City rodeo singing performance at age 19 (she belted out the national anthem and caught the ear of country artist Red Steagall, who helped get her her first record deal), the singer has seldom slowed down. When not racking up music accolades (she has two Grammys, six CMA Awards and a record seven wins as the Academy of Country Music's Top Female Vocalist), Reba branched out into acting, spending six seasons as the star of the TV sitcom *Reba,* appearing in seven films and winning acclaim for performances on Broadway in *Annie Get Your Gun* and *South Pacific.* She has also found time to launch her own line of clothing and home accessories as well as raise Shelby, 21, her son with manager Narvel Blackstock, her husband of 22 years. "Narvel always says I have the attention span of a 2-year-old," says the singer with a laugh. "I can't be bored. I'm always looking for new things to do."

THE MANY SIDES OF REBA

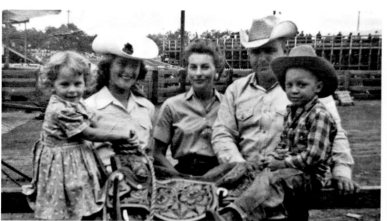

1958 | At the Pendleton, Ore., rodeo as a toddler (far left) with that year's Rodeo Queen, mom Jackie, father Clark and brother Pake.

2007 | On the set of *Reba.*

1990 | With Michael Gross in the film *Tremors.*

2001 | Performing on Broadway in *Annie Get Your Gun.*

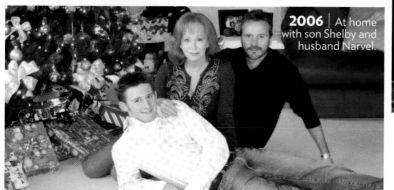

2006 | At home with son Shelby and husband Narvel.

BROOKS & DUNN

In the beginning there was Brooks: Kix Brooks, the son of a Louisiana oil worker who traded the beer halls of Cajun country for the honky-tonks of Nashville. And there was Dunn: Ronnie Dunn, a lanky Bible college dropout who won a Nashville recording session in a talent contest. Each had dreams of writing songs and scoring a record deal, but their solo careers were on the slow track until Tim DuBois, head of Arista's Nashville division, stepped in and played matchmaker.

He introduced Brooks to Dunn over lunch at a Mexican restaurant; their second date was a songwriting session. After listening to a tape of

their work together, DuBois offered the two men a deal—as a duo. "Ronnie and I were the most unlikely duo candidates," says Brooks. "We had always held on to single egos." But with both men in their mid-30s, their prospects for solo stardom were dimming. They decided to give it a shot.

In 1991 the first song they wrote together, "Brand New Man," became Brooks & Dunn's first chart topper, and together they became an unbeatable force for the next two decades. Between their first single as partners and their last ("Honky Tonk Stomp" in 2009), they scored 23 No. 1's, sold more than 30 million albums and

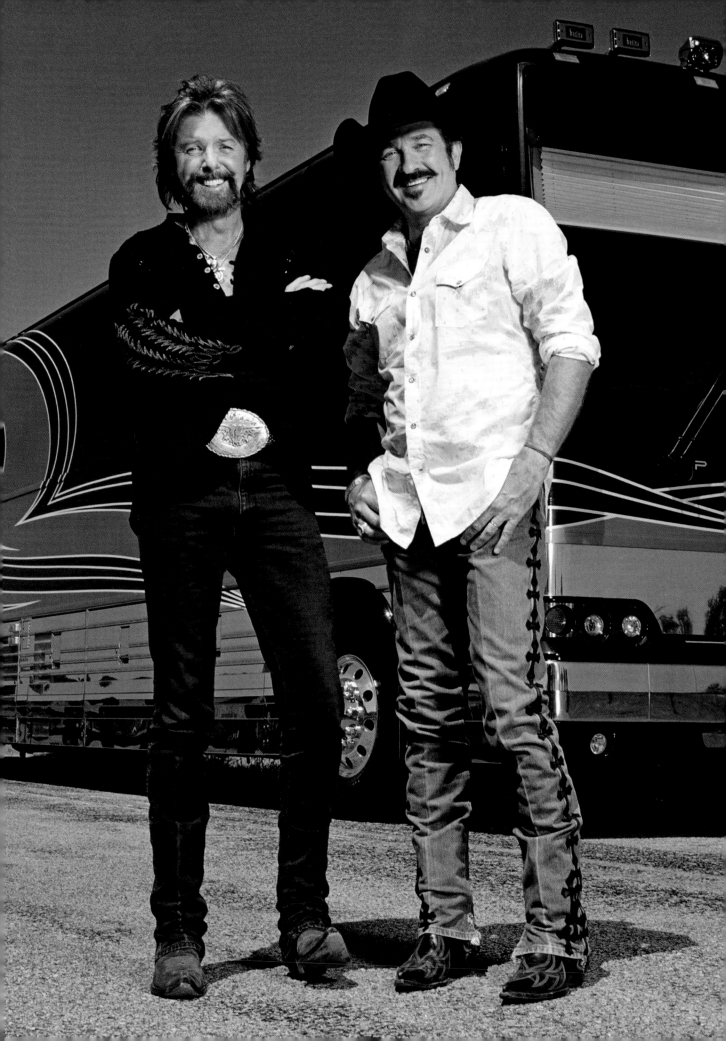

c. 1985 "It took us about 40 years combined, but we finally got out of those danged bars," quipped Dunn of their delayed start as a duo.

2011 Dunn's first single as a (post-B&D) solo artist, "Bleed Red," hit the Top 10.

nabbed the CMA's Vocal Duo of the Year a record 14 times. Their tours packed arenas from coast to coast. "We've always looked at an arena as just a bigger honky-tonk," Dunn says. Adds Brooks: "There's nothing more intimate than 15,000 people all focused on the stage."

On August 10, 2009, Brooks & Dunn posted a joint statement on their website: "After 20 years of making music and riding

> **It's really all about the music. You can dress up and look pretty, but it all revolves around the songs** —RONNIE DUNN

this trail together, we have agreed as a duo that it's time to call it a day." Although both Brooks, 56, and Dunn, 58, plan to continue making music as solo artists, the pair made their final performance as a duo in August 2010. Says Kenny Chesney: "They are a chapter in history that's going to stand for a long time, not just in country music—in American music."

1990 | Before joining forces with Dunn, Brooks wrote songs for John Conlee, the Nitty Gritty Dirt Band and Highway 101.

2011 | Brooks (in *Thriftstore Cowboy*) is dabbling in movies.

ALAN JACKSON

Jackson's fans may love him for promoting the joys of happy hour in the song "It's Five O'Clock Somewhere," but his wife, Denise, appreciates him the most at a different time of day. "Alan always sets the coffee pot at night because I don't want to wait for it to brew in the morning," she explains. "It seems like such a simple thing, but it means a lot."

That romantic side—and attention to detail—is also evident in her husband's massive catalogue of hit songs (26 No. 1's and counting!). Whether he's singing about the joys of goofing off in "Chattahoochee," paying tribute to his late father in "Small Town Southern Man" or channeling the country's grief over 9/11 in the poignant "Where Were You (When the World Stopped Turning)," Jackson's lyrics are always brimming with heart. "I wish I knew the magic ingredients," Jackson, 52, says about his career. "I've been lucky to have songs that have an impact."

That's quite an understatement—even for the soft-spoken cowboy from rural Newnan, Ga. His way with words has led to a trove of awards— 17 CMAs, 16 ACMs and 2 Grammys—and a reputation for keeping country music's legacy. "Not many people still do traditional country music,"

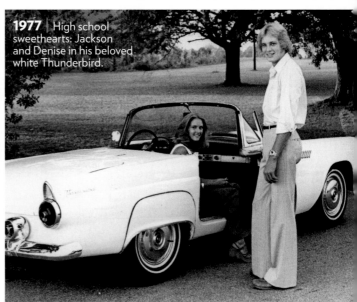

"I've never felt like a great singer," says Jackson (in the early 1990s). "I like my songwriting, but I always wished I could be more like Merle Haggard."

ALAN JACKSON: THROUGH THE YEARS

ca. 1959 | Jackson playing in the yard at home with his dad, Eugene.

1977 | High school sweethearts: Jackson and Denise in his beloved white Thunderbird.

> "I don't really have any formal training, but I've always heard the melodies well. It still amazes me"

he says. "Maybe that's why I still sell a few records and tickets."

Never forgetting where he comes from also helps him connect with fans. The son of a Ford mechanic, Jackson grew up poor in a house his granddad converted from a toolshed. He slept in a hallway until he was 10 and the eldest of his four older sisters moved out. "When I was growing up, we never did have anything," he says. At age 21, Jackson married Denise, his high school sweetheart. "She was this beauty queen and the No. 1 catch in the whole school," he recalls. "I was just the regular guy." In fact it was Denise who finally got him his break: A flight attendant at the time, she cornered Glen Campbell in the Atlanta airport and took his card. Within a year Jackson had moved to Nashville and was writing songs for Campbell's publishing company. He signed a record deal a few years later. His 1990 debut album, *Here in the Real World,* had four Top 5 songs, including his first No. 1, "I'd Love You All Over Again." From then on every album spawned multiple hits, including "Tall, Tall Trees," "Little Bitty" and "Remember When." To date, he's sold nearly 60 million records.

But while his career soared, his personal life was bumpier: He and Denise weathered a very public separation in 1998. "We were just kids when we started out," explains Jackson. "We didn't know anything and got on the wrong track." Now reconciled, they say they are more committed than ever to their marriage and daughters Mattie, 21, Ali, 17, and Dani, 13. "We survived a roller coaster, and we're in good shape," says Jackson. That kind of experience really resonates with his fans. "Even though I live in an unreal world," he says, "I still have been able to understand real life."

'90 | "I'm pretty average," says Jackson. "We're not socialites."

2009 | A family portrait: Jackson, Denise and daughters Dani, Mattie and Ali.

The
NEW GENERATION

Making their own mark on Nashville

LADY ANTEBELLUM

On a spring night in 2006, Charles Kelley was out grabbing a beer at a Nashville bar when an aspiring singer named Hillary Scott came over and introduced herself. "She said, 'I love your music.' And I just thought, 'Oh hey! A pretty girl!' recalls Kelley. Then he got home and started Googling. "I looked up her stuff on the Internet and realized this girl is the real deal!" A week later Kelley (left), 29, Scott, 25, and Kelley's roommate and close friend since they met in middle school in Augusta, Ga., Dave Haywood, 29, sat down to write music together for the first time. "It all kind of miraculously happened," says Scott. Five years later they're a triple-platinum, genre-busting trio with five self-penned No. 1 hits (including the crossover smash "Need You Now"), a bookshelf full of trophies and a headlining world tour. "From that first day we wrote together, it just felt right," says Haywood. "There was so much chemistry among the three of us, we knew it was something we had to chase."

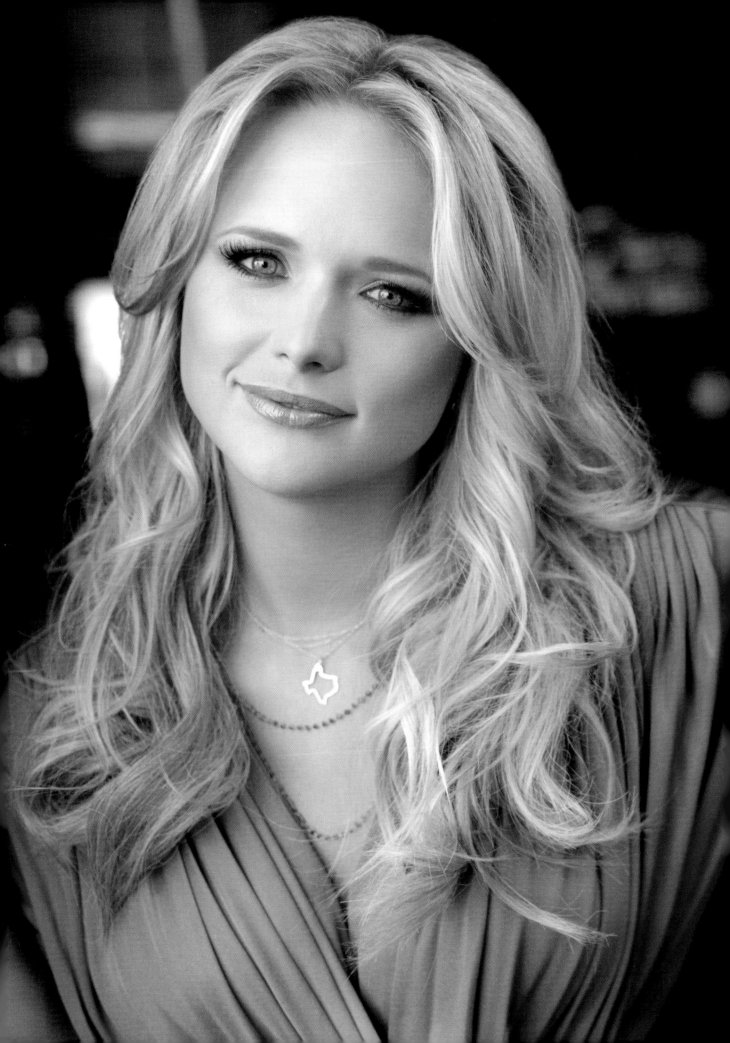

MIRANDA LAMBERT

The singer who counts hits like "Kerosene," "Crazy Ex-Girlfriend" and "Gunpowder and Lead" among her set list wants to make one thing clear: That's not who she is—anymore. "There are a lot more sides to me than just the crazy," says the Texas native, who wed singer Blake Shelton in May 2011. "The girl who blows stuff up and is terrifying—that was fun and that's who I was in my early 20s trying to prove myself, but now I'm 27 and I have a lot more to say."

And people are listening. Lambert's third album, *Revolution,* went platinum, spawned the No. 1 hits "The House That Built Me" and "Heart Like Mine," scored a record nine CMA nominations and earned Lambert her first headlining tour. "Kenny Chesney's not coming out after me this time," she says. "I get to be the artist on last. The crowds are there for me." And Lambert isn't done yet. "I want to be Loretta Lynn," she says. "I strive for that big, that long and that important of a career."

JASON ALDEAN

The Georgia native knows how to wait for what he really wants. Aldean always wished he could rock an earring—just like his idols in Bon Jovi and Guns N' Roses—but he held off because it was against the rules at his high school. "I graduated and literally got up the following morning and got my left ear pierced," he says. (Soon he had the right one pierced too.) He's been just as patient with his career. After two broken deals in the early 2000s, Aldean, now 34, finally struck gold with a No. 1 song, "Why," on his 2005 debut album. Since then, the tough-but-tender guy who married his high school sweetheart and dotes on his daughters Keeley, 8, and Kendyl, 3, has sold millions of albums and had five more songs reach the top spot on the Hot Country Songs chart, including "Big Green Tractor," "The Truth" and "Dirt Road Anthem." The success is definitely his kinda party. "I get to make a living doing something I really love to do," he says.

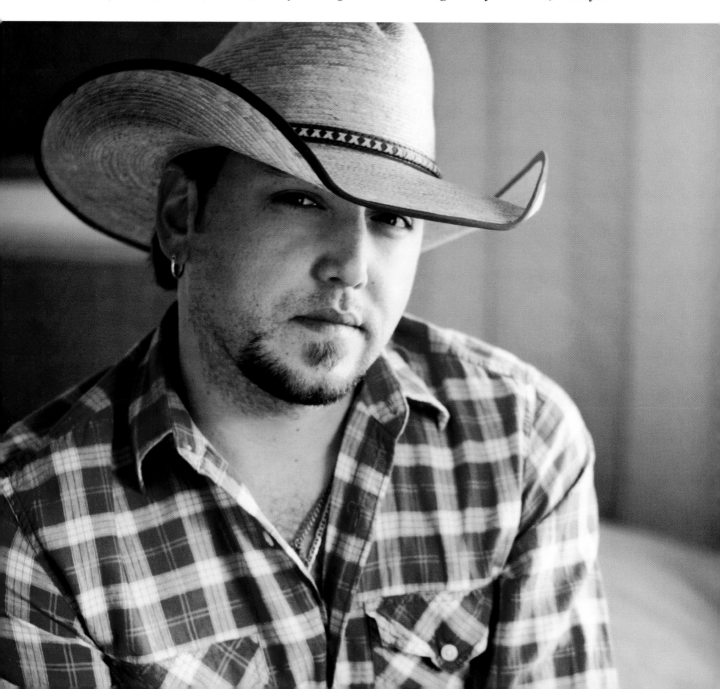

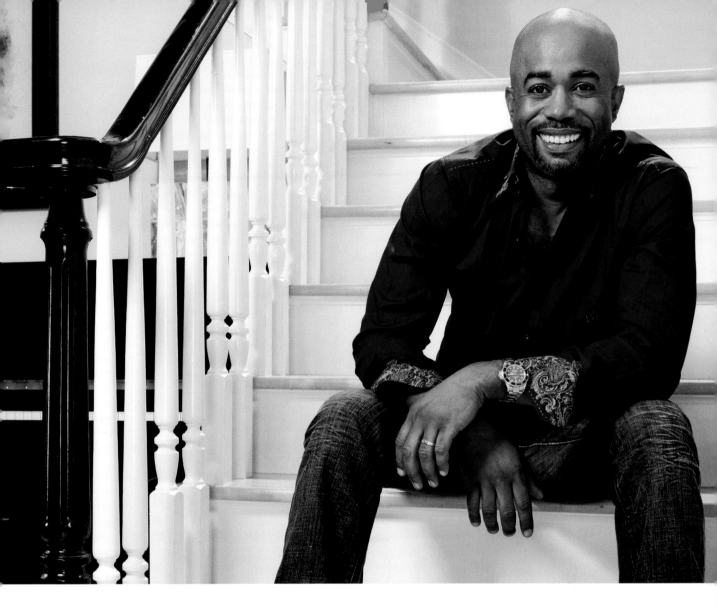

DARIUS RUCKER

When Rucker made the transition from the pop-rock group Hootie and the Blowfish to country in 2008, he admits he was a bit nervous about the reaction he'd get. "We didn't know if the fans were going to go, 'What's Hootie doing over here?'" he says with a laugh. So the lifelong country music fan went hardcore, initially packing his genre debut, *Learn to Live*, with songs he now admits might have been a little *too* country. "I wanted to record the countriest things we had," he says. "But the president of the label listened to it and said, 'I love 'em, but I don't know if George Strait could get these on the radio!'" Fortunately, once the rejiggered release

dropped, it took off, selling about 1.5 million copies and scoring the South Carolina native five No. 1 hits, including "Don't Think I Don't Think About It" and "Alright." His critically acclaimed 2010 follow-up, *Charleston, SC 1966,* topped the charts as well, cementing Rucker's place in the country pantheon. "I hear from people who go, 'I never listened to country music until I heard you, and now I listen to country all the time,'" says the 45-year-old father of three. "That really feels good." So does being called by his own name. The old, "Hey, Hootie!" shout-out from fans is all but extinct, says Rucker. "Maybe now," he adds, smiling, "we can change it to Darius."

BLAKE
SHELTON

To say it's been a crazy, jam-packed time for Shelton might be a bit of an understatement. He got inducted to the Grand Ole Opry in October 2010. He took home his first CMA award in November. He got hitched to fellow country singer Miranda Lambert in May, and he's been holding down a spot—and an armchair—as a "voice coach" alongside Christina Aguilera, Cee Lo Green and Adam Levine on NBC's hit reality show *The Voice*. "We're put on a level playing field with our contestants—I love that," says Shelton, 35. "Right there on national television, a singer might say, 'Uh, I don't think so, Blake!'"

In fact, the Ada, Okla., native insists he never strays too far from his roots. "Hell, I still live in Tishomingo, Okla.!" he says. Shelton, who got his musical start playing clubs around Ada, won a statewide contest for young entertainers when he was 16. A year later the ambitious teen packed up his guitar and moved to Nashville to try his hand at country music stardom. "[My mom was] smart enough to know had she tried to stand in my way, we would have probably gotten sideways over it," Shelton told the website the Boot.

After years of making the rounds in Nashville, his self-titled debut album finally arrived in 2001 and produced his first No. 1 single "Austin," which spent five weeks at the top of the charts. Nine No. 1 hits later, he's back "living a regular life" only 40 miles away from his hometown with his new bride Lambert, whom he met while they were taping a CMT special in 2005. "We got up there onstage for rehearsal and something just happened," he says of their first meeting. "I think we both knew it." And the singer, who was previously wed for nearly three years to hometown girlfriend Kaynette Williams, says he's determined to make this marriage work—if only out of self-preservation instincts. Quips Shelton: "If you think Miranda owns guns, her dad could fill up a Bass Pro Shop with his guns and ammunition!"

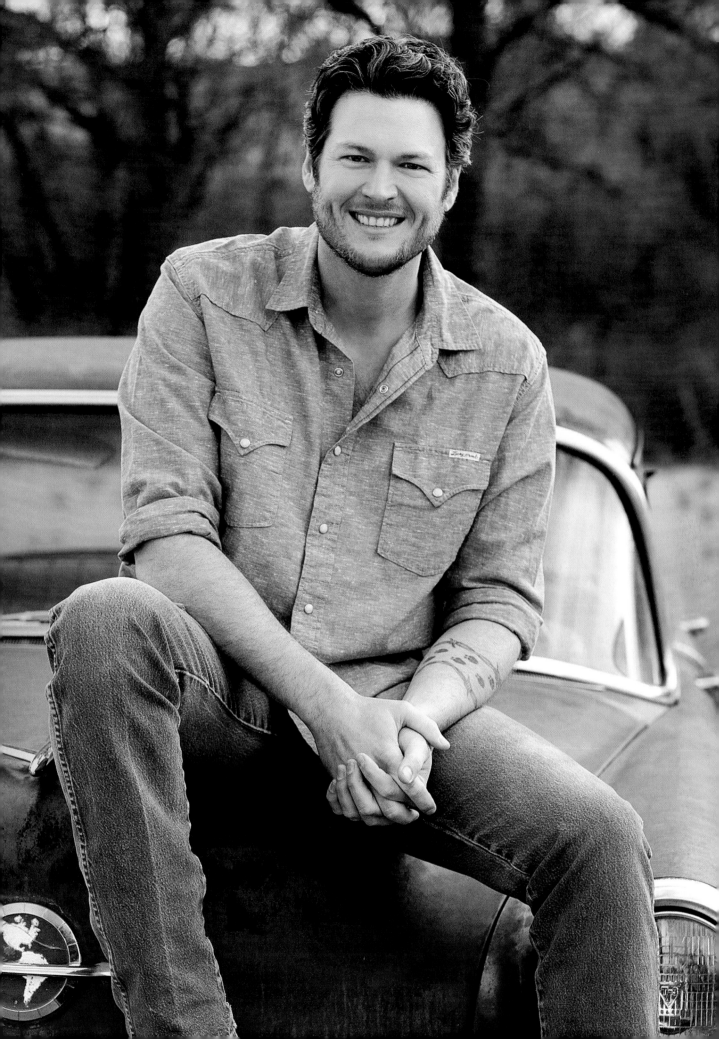

THE ZAC BROWN BAND (clockwise from bottom left): Zac Brown, Jimmy De Martini, Clay Cook, John Driskell Hopkins, Chris Fryar and Coy Bowles.

ZAC BROWN BAND

His band had already racked up six No. 1 hits and won two Grammy Awards, but the highlight of Zac Brown's fast-rising music career came in April 2011, when his band took the stage at the Academy of Country Music Awards to perform "Colder Weather," with his personal hero, music legend James Taylor. The performance was the "all-time best musical moment of my career," Brown, 32, said afterward. The memories, however, are rapidly piling up for the Georgia-based band, which burst onto the country scene in 2008 with the double platinum-selling album "The Foundation" and its string of infectious No. 1 singles like "Chicken Fried" and "Toes." The band—comprising Brown, fiddle player Jimmy De Martini, bassist John Hopkins, drummer Chris Fryar and guitarists Coy Bowles and Clay Cook—has so far racked up three more No. 1 singles (including "Knee Deep" and "As She's Walking Away") off its second studio CD, 2010's *You Get What You Give*. Brown, who began playing classical guitar as a child in Dahlonega, Ga., says he's humbled by the success: "There's no way to predict how fast everything is going to come together."

RODNEY ATKINS

Nothing's ever come easy for Atkins. Frail and sickly as a baby, he was adopted and returned to a children's home twice before finding the love of a permanent family. His singing career was another kind of endurance test. After leaving his native east Tennessee for Nashville, he languished on the country scene for nearly a decade before finally scoring his breakthrough in 2006 with the album *If You're Going Through Hell*. As with his home life (the singer now has a 9-year-old son and two stepdaughters with wife Tammy Jo—"Family is something I don't take for granted because I'm so fortunate to have one," he says), his singing success was worth the wait. *If You're Going Through Hell* went platinum and spawned four No. 1s, including "Watching You," an ode to everyday fatherhood that was named Billboard's Hot Country Song of the year in 2007. "It's important to me to record songs that are about things that are real," says Atkins, 42. "When you write a song that moves so many folks, that's the closest we ever come to real magic other than having our children."

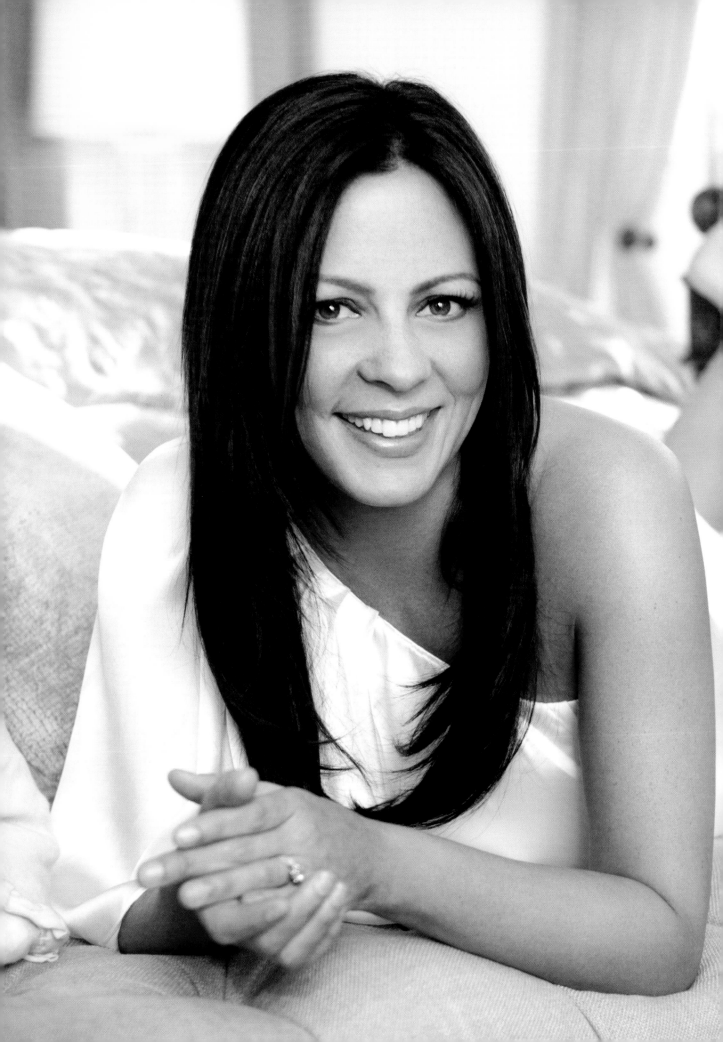

SARA EVANS

Evans has pluck to spare. At age 4, she was belting out "Delta Dawn" with the Evans Family Band. She was 8 when both of her legs were broken by a speeding auto and she had to learn to walk again. At 16, she drove more than an hour from the family farm in Boonesboro, Mo., to play weekends at the Country Stampede club near Columbia. "I learned to perform there," she recalls. "It taught me how to look at the audience and smile." So it was no surprise to her parents and six siblings that at 20, she drove her Ford Festiva east to Nashville. "I was afraid of being in a big city, but I wasn't afraid of trying to get a record deal. I was determined to do that."

It took two trips to Music City, but once songwriter Harlan Howard heard her sing, he urged friends at RCA Records to give a listen and she had her deal. A succession of platinum albums and No. 1s followed, including the autobiographical "Born to Fly," "Suds in the Bucket" and "A Real Fine Place to Start."

Then her personal life imploded. Midway though her appearance on the 2006 season of *Dancing with the Stars*, Evans abruptly quit the show and filed for divorce from Craig Schelske, father of her three children. The split was bitter as both sides accused the other of infidelity. Devastated, Evans retreated from the spotlight. But soon, through her pastor, she met former University of Alabama quarterback Jay Barker, a newly divorced dad with four kids of his own, and love bloomed. "It was hard for me to believe that he was real," she says. "I thank God every single day for bringing us together." In 2008 they married and she and her kids set up home with Barker in Birmingham, Ala.

With her new husband's support, Evans, 40, has turned back to her career. "God blessed her with this voice," he says. "I want her to do what she does, chase her dream." Five years after her darkest place—and her last album—she soared to the top of the charts with her single "A Little Bit Stronger." Now she's ready to hit the road running again. "With Jay and all seven kids out there, it's so wild and fun! It's the best thing in the world."

JOE NICHOLS

By the summer of 2007, Nichols finally had the career he'd been working for. He had a platinum album and two No. 1 singles under his belt ("Brokenheartsville" and "Tequila Makes Her Clothes Fall Off") and no less an icon than George Jones had called him "the future of traditional country music." Then just a month after his wedding to longtime girlfriend Heather Singleton, Nichols abruptly canceled a tour and checked himself into rehab for alcohol abuse. The road back has been hard, but Nichols, 34, is determined to see it through. He scored a No. 1 single in 2010 with "Gimme That Girl."

"[The past] is a chapter that's a painful one, but it does not define me," he says, "but I think I'm a lot better than I ever have been."

BILLY CURRINGTON

There's the sexy video for "Must Be Doin' Somethin' Right," where a shirtless Currington rolls around in the surf. There's the fact that he complains about his hair. ("It can flip the wrong way," he says, "and then it looks weird.") And did we mention his 2005 photo spread in *Playgirl*? But despite evidence to the contrary, Billy Currington is no mere pretty boy. Since his Nashville debut in 2002, he's racked up six No. 1 hits, including "Good Directions," "People Are Crazy" and "Pretty Good at Drinkin' Beer." And at a recent rodeo gig, Currington, 37, was eager to remind his fans that he's really just a country boy from rural Rincon, Ga., who grew up riding a neighbor's bronco for fun. "These guys were gonna let me ride a bull," he says with a laugh, "but someone stepped in and wouldn't let me do it."

DIERKS BENTLEY

As a young teen, Bentley boasted a CD collection that was distinctly twang-free. "It was great '80s hair bands—Skid Row, Whitesnake, Black Sabbath," says Bentley, who at the time even tried to tame his own famous curls into spikes a la Billy Idol.

Then he discovered country. Though his dad played George Strait and Hank Williams as Bentley was growing up in Phoenix, it was Hank Jr. that struck the first chord with the rowdy teen. At 19, Bentley had moved to Nashville and soon began hanging out backstage at the Opry, frequenting bluegrass mecca the Station Inn and penning his own tunes. At 20, "I was so militant about country music, I took all those [old rock] CDs and tried to sell them," he says.

After eight years playing Nashville honky-tonks "writing country music and living country songs," as his pal, cowriter Brett Beavers, recalled, Bentley began churning out his own platinum-selling discs with his 2003 self-titled debut and 2005's chart-topper *Modern Day Drifter*. He scored a string of No. 1s like "What Was I Thinkin'," "Come a Little Closer" and "Am I the Only One," and found love with childhood friend and now wife Cassidy. But in 2010, Bentley, 36, took a detour from radio-friendly hits with the risky bluegrass-inspired *Up on the Ridge*. "I needed to make this record and didn't care what people thought," says the singer. Not to worry: The record earned him critical acclaim and three Grammy nominations. "And it was the most fulfilling feeling," he says.

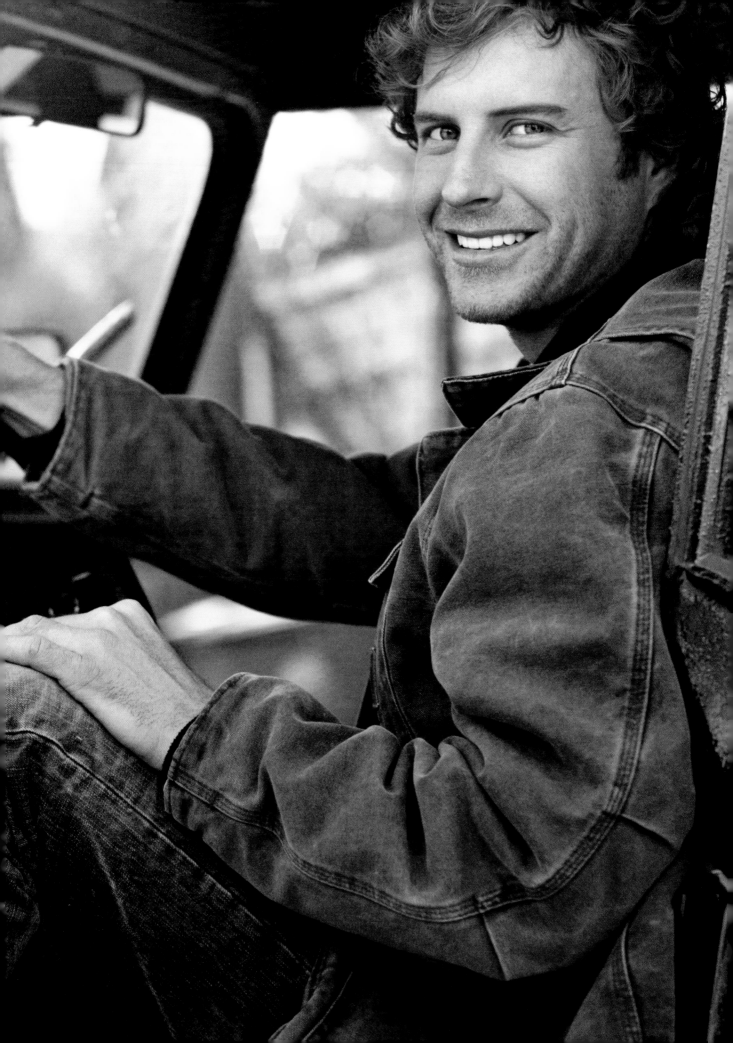

BREAKTHROUGHS

The superstars of tomorrow

THE BAND PERRY

The band of siblings—Reid, 22, Kimberly, 27, and Neil, 21—from Greeneville, Tenn., caught everyone's attention with their 2010 crossover smash "If I Die Young." It's actually more about "living life" says Kimberly, who wrote the song while sitting on her bed one day. That same afternoon she took it to the basement to share with her brothers, who "were right onboard with it," she says. "Then my mom came down in the middle of the writing process and said, 'I don't want to hear you sing about death!—but I love it!'" In fact the band, who spent 346 days on the road last year, credit their parents with building the foundation for their success. "Dad was the question asker when we first started, and Mom's the referee," says Kimberly. There's one key piece of advice from Mom that has served them especially well. "We drive each other absolutely nuts, always have," says Kimberly. "I remember Mom taking us to a window and saying, 'You see that? That's a big world out there, and you're going to have to fight in it everyday. So you're not going fight each other in this household,'" recalls Kimberly, adding, "That little bit of advice has come in mighty handy!"

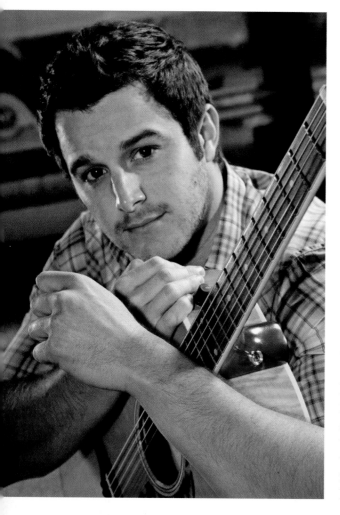

EASTON CORBIN

Bursting onto the scene in 2010 with the ode to small town life "A Little More Country Than That," Corbin became the first male artist to score a No. 1 hit with his debut single since Dierks Bentley did it in 2003. It was a song even George Strait had passed on as "too country," so why'd the newcomer choose it? "It's who I am. I grew up surrounded by dirt roads, just like in the song," says the farm boy turned singer from rural Florida. Though he admits even he was surprised by its success. "I knew it was a good song, but I didn't know it was going to be that type of hit!" And proving that he's no one-hit wonder, Corbin, 29, followed it up with a second No. 1, "Roll with It."

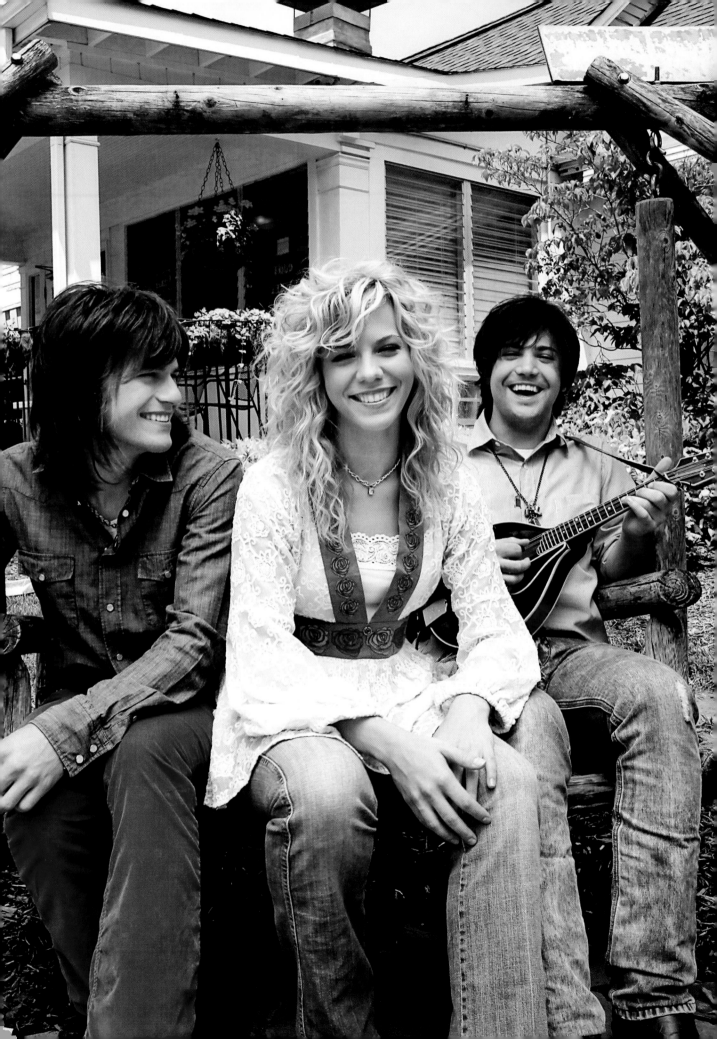

CHRIS YOUNG

It wasn't the first time he heard his song on the radio. Or even the first time someone asked him for an autograph. The moment that told Young he had truly made it as a star was a little different. "It was the first time a bra came onstage!" says the Murfreesboro, Tenn., native, 26. "As a guy musician, you know the first time underwear flies onstage that you're connecting on that level." Now with a string of No. 1 hits—"Gettin' You Home," "The Man I Want to Be," "Voices" and "Tomorrow"—the bras are piling up. And the (single!) singer-songwriter confesses he's a romantic at heart. "I write about being in love," he says. "I'll take you out to dinner, and I'll hold the door for you; but at the same time, I might emulate Conway Twitty and 'lay you down' later on. My music can do both sides."

LUKE BRYAN

When the singer from Leesburg, Ga., first hit Nashville in 2001, he had a backup plan in place. "I've always said, I have a nice thing to fall back on if the music thing doesn't work," says Bryan, 34. "I could go back and help my dad with his agriculture business and have an enjoyable life." Clearly, the farm will just have to wait. He hit the top of the charts in 2010 with the singles "Rain Is a Good Thing" and "Someone Else Calling You Baby."

ERIC CHURCH

He's a country outlaw—with a B.S. in marketing. The singer from Granite Falls, N.C., delayed his move to Nashville for two years, after his dad agreed to fund his first six months in Nashville if he finished school first. When he finally did get to Music City, Church scored a string of top 20 hits like "Love Your Love the Most," "Hell on the Heart" and "Smoke a Little Smoke," and built a cult following at his live shows. He also developed a unique preshow ritual in the process. "Jack Daniels," says Church, 34. "A lot of people do vocal exercises and crap. My vocal warm-up is a shot or two of Jack."

BEHIND THE LYRICS

The stories behind some of country's biggest songs

"FRIENDS IN LOW PLACES"

GARTH BROOKS

I t has become one of country's most beloved blue-collar anthems, and it helped launch Garth Brooks into the stratosphere. But Brooks's signature song got its start in a humble lunch-tab discussion at Nashville's Tavern on the Row back in the mid-'80s. Songwriting partners DeWayne Blackwell and Earl Bud Lee were finishing a midday meal, and Blackwell asked how they'd pay the bill. "I said, 'Don't worry about it,'" recalls Lee. "'I've got friends in low places.'" The pair immediately knew they were onto something good, but it took another year—and another meal, this time brunch at O'Charley's—for them to start writing. When they finally did, the lyrics "pretty much came out in 20 minutes," says Lee. (Alas, the original draft—scrawled on a napkin—has long since been lost.) "We went to DeWayne's apartment, picked up the guitar, and the melody came out."

Brooks, fresh off releasing his self-titled first album, came across "Friends" when he was asked to record the demo for the song, his last as a session singer. "I sang the session out in Hendersonville," Brooks recalled in the liner notes to 1994's *The Hits,* "and for the next two weeks the chorus to this song kept running through my head. I asked Bud Lee and DeWayne if I could hold on to it, and without a blink of an eye, they both said yes." Appearing on Brooks's 1990 CD *No Fences,* the song spent four weeks at No. 1 and won CMA's Single of the Year. What about the (slightly) naughty "third verse" Brooks adds in concert? Says Lee: "I love it!"

"Things got real crazy" after Brooks recorded "Friends," says Lee (right, with Blackwell and Brooks) at the ASCAP party honoring the smash song in September 1990.

I've Got Friends in Low Places

Blame it all on my roots I showed up in boots
and ruined your black tie affair
the Last one to Know the Last one to Show
I was the Last one you thought you'd See there
and I Saw the suprise and the Fear in his eyes
when I took his glass of Champagne
then I toasted you and said we may be through
But You'll never Hear me Complain

Cause I've got Friends in Low Places
where the whisky drowns and the beer chases
my blues away and I'll be OK
Oh I'm not big on Social graces think I'll slip
on down to the Oasis Oh I've got Friends in Low Places

Well I guess I was wrong I just don't belong but then
I've been here before everythings olright I'll just
say good night and I'll show myself to the door

hey I didn't mean to Cause a big Scene but give
me an hour and then I'll be as high as that
Ivory tower You're Living in

Cause I've got friends in Low Places
Where the whisky drowns and the beer chases
my blues away and I'll be OK Oh I'm not
...

In the liner notes for 1994's *The Hits*, Brooks thanked Lee and Blackwell for giving him "Friends"—first recorded by Mark Chesnutt—back when he was "an unknown artist . . . thanks DeWayne and Bud for believing in me."

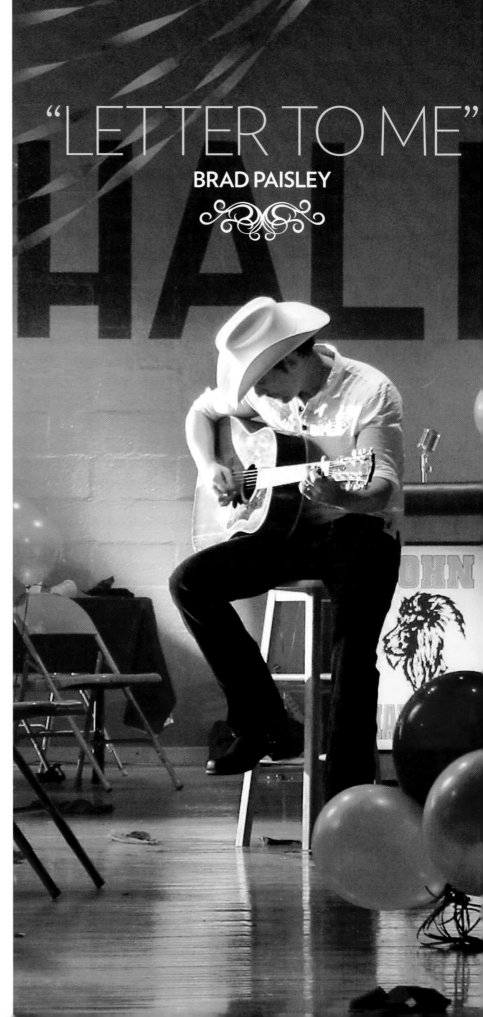

"LETTER TO ME"

BRAD PAISLEY

Just weeks before the birth of his first son, Huck, in 2007, Brad Paisley sat down at his California home in a pensive mood to pen songs for what would become his *5th Gear* album. "My wife was asked to write a story for a book that was a collection of women writing letters to younger women telling them what they wish they had known," Paisley says. "I started thinking how it would be a really good idea to write a letter to yourself when you were younger." The resulting "Letter to Me" was "a bit of a love song to yourself, saying, 'You're going to like who you are, and I really do care about who you are and who you become,'" he explains. Nearly every line in the song, which became Paisley's 10th No. 1, rings true to his own life. "It's so personal in every way, like you're opening your heart right up and saying, 'Here's all the things I was afraid of, here's the people I miss, here's who I am and the reason I am who I am, here's some of the mistakes I've made.'" Mrs. Brinkman, his speech teacher at John Marshall High School in Glen Dale, W.Va., did "see the diamond underneath," as the song says; a girl named Bridgett really was his prom date; and he did lose his Aunt Rita to breast cancer in 2004. He admits taking a few lyrical liberties, however. That "Skoal can and a *Playboy*" under the bed? His true hidden treasures were a different kind of contraband: "I kept a handheld transistor radio and a flashlight under the bed. There were magazines, but they weren't dirty. They were science fiction."

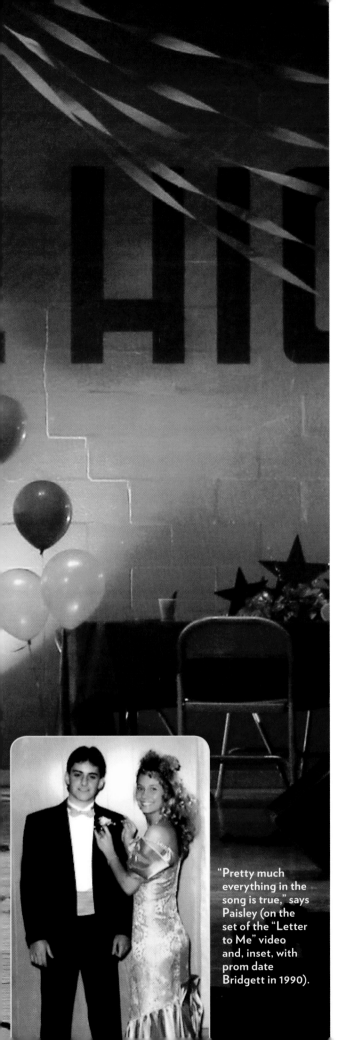

"WITHOUT YOU"

KEITH URBAN

The traveling and the singing; the fast cars and the guitars; true love and a baby girl: Keith Urban's ode to contentment would seem to be an intimate glimpse into the singer's life with wife Nicole Kidman and their daughters. In fact, says the song's co-writer Dave Pahanish, "it's the exact story of *my* personal life!" Pahanish penned the tune (along with cowriter Joe West) about meeting his wife, Kristin, and her family, and his subsequent good fortune when a song he cowrote for Jimmy Wayne, "Do You Believe Me Now," "climbed like a bullet" to No. 1. Urban discovered "Without You" (a No. 1 hit for him) after singer Emily West passed it to him, telling him, "It's perfect for you." Says Urban: "People say that all the time, but I got a copy of it and said, 'Wow, this is amazing.' It was a no-brainer that I'd cut it. One of the most autobiographical songs I never wrote!"

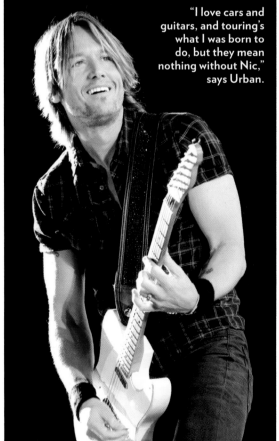

"I love cars and guitars, and touring's what I was born to do, but they mean nothing without Nic," says Urban.

"Pretty much everything in the song is true," says Paisley (on the set of the "Letter to Me" video and, inset, with prom date Bridgett in 1990).

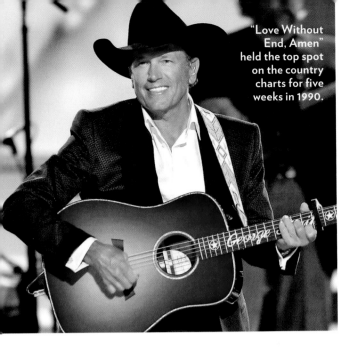

"Love Without End, Amen" held the top spot on the country charts for five weeks in 1990.

"LOVE WITHOUT END, AMEN"
GEORGE STRAIT

When Strait first heard songwriter Aaron Barker's tribute to a father's unconditional love, the sentiment immediately hit home for the Texas cowboy, who was raised by his divorced dad, John, and whose son George Jr. (Bubba) was born the year his first single, "Unwound," was released. "Aaron told me he wrote this song after an argument with his son," Strait explains. "When he played it for me, we just changed it to the year Bubba was born, 1981. I really like the message."

And Strait wasn't the only dad touched by the lyrics. It was also a personal favorite of President George H. W. Bush, who invited Strait to perform the song for family and friends at Camp David one weekend. "This was about the time we were having so many problems overseas, so he kept being called away," recalls Strait. "I sung it while he was out of the room, and when he came back, he asked that we do it again, so we did. We were very fortunate to be invited." Laughing, he adds, "I did have to go out jogging about two miles with him and I wasn't really used to that, but I managed to hang in there."

"FANCY"
REBA McENTIRE

Any true Reba fan knows there's one thing you can always expect from a Reba concert: "They know I'm not done with a show until I do 'Fancy,'" the singer says. Released in 1969 by Bobbie Gentry, the song tells the tale of a young girl who overcomes poverty to become a high-end escort. It was a crossover success for Gentry, who once described it as "my strongest statement for women's lib." But Reba had to fight to record her own version. "I loved it when Bobbie had it out and I'd sing it in bars and clubs and rodeos," Reba says. "People would say, 'You can't dance to it!' I'd say, 'I don't care! Sit down and listen to it!'" In the '80s she asked her producer Jimmy Bowen about recording it, but he rejected the idea, telling her, "You don't want to do that—it's about a prostitute!" Finally she found a kindred spirit in producer Tony Brown, who put it on her 1990 album *Rumor Has It*. It became a Top 10 hit when Reba released it in 1991. "It was his favorite too," she said. "It's an incredible song."

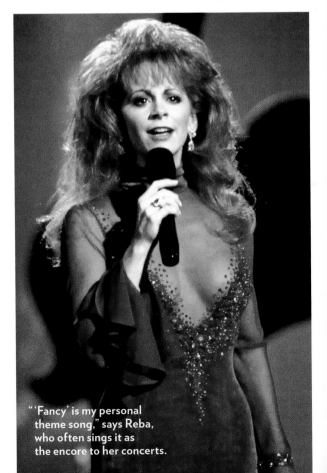

"'Fancy' is my personal theme song," says Reba, who often sings it as the encore to her concerts.

"THE BOYS OF FALL"

KENNY CHESNEY

B efore he was a country superstar, Kenny Chesney was a high school wide receiver under the Friday-night lights in Luttrell, Tenn. "I only played two years," the singer says. "But those two years hold some of the best memories of my life. The fun, the rush, the agony, the practices, wearing your jersey to school on game days and the feeling when you hit the field on a Friday night." Written by Casey Beathard and David Turnbull, "Boys of Fall," Chesney recalls, "was everything getting dressed and being on that field felt like. And it's a feeling you never want to let go of." The song, which appeared on Chesney's 2010 album *Hemingway's Whiskey*, "is a perfect description of how I grew up and where I grew up. . . . There's a line that says, 'In little towns like mine, that's all we got.' And that's the way it was in East Tennessee, and still is." As for his own experience on the gridiron, says the singer, "I honestly believe that if I'd not played high school football, I wouldn't be where I am today."

The song was the 18th No. 1 hit for sports fanatic Chesney (working out with the New Orleans Saints in Cincinnati in 2007).

"NEED YOU NOW"

LADY ANTEBELLUM

I t began with just two chords. "Charles had just started learning to play guitar and used the two chords he knew—the C and the E minor—and was like, 'I have this little verse melody,'" says Haywood. As Kelley passed the guitar to more accomplished instrumentalist Haywood, the group and cowriter Josh Kear played with the "spooky feel" of the music, and someone mumbled the line "Picture perfect memories, scattered all around the floor." From there a multiplatinum hymn to heartbreak was born. In crafting the remaining lyrics, "we all pulled from places we've been," Haywood says. Bandmate Hillary Scott had recently broken up with a boyfriend in an ending she calls "Lifetime movie-esque. I was cheated on, lied to. I was pissed and I was hurt." Originally the song was meant to be a solo for Scott, "but I was like, I don't want to be the only one singing 'I'm a little drunk and I need you now,'" she says with a laugh. "So we made it a duet." But all three dismiss charges it's a mere "booty-call song." "For men, sometimes it takes going out and having a few drinks to become a little vulnerable," says Kelley. "The only time you open up much is when it's late at night and you're a little drunk." Haywood agrees. "It's just honest," he says. "And we wanted the song to be honest."

Need you now

Writers: Lady Antebellum + Josh Kear
Dave Haywood, Charles Kelley, Hill Scott

V1
picture perfect memories scattered all around the floor
Reaching for the phone cause I can't fight it anymore
And I wonder if I ever cross your mind
for me it happens all the time

CH
It's a quarter after one, I'm all alone + I need you now
Said I wouldn't call but I lost all control + I need you now
+ I don't know how I can do without
I just need you now

V2
Another shot of whiskey can't stop lookin @ the door
Wishin' you'd come sweeping in the way you did before
And I wonder if I ever cross your mind
for me it happens all the time

CH
It's a quarter after one, I'm a little drunk + I
need you now
Said I wouldn't call but I lost all control + I need you
now

"I thought it was cool, but maybe felt too indie," says Haywood of his expectations for "Need You Now." "I honestly didn't think it would even get to the point of recording."

"THE HOUSE THAT BUILT ME"

MIRANDA LAMBERT

Good thing Miranda Lambert and Blake Shelton are the kind of couple who believe in "what's mine is yours." The pair were driving home from the airport in 2008 when they popped in a CD of music being pitched to Shelton for his next album. "I knew the very first moment I heard it, it was special," says Lambert of "The House That Built Me," by songwriters Tom Douglas and Allen Shamblin. Having grown up in an old farmhouse in Lindale, Texas, that her dad fixed up little by little, Lambert connected with the song's lyrics, and by the time it hit the chorus, she was bawling. "I took one look at her and just said, 'If you have this strong of a reaction to a song, you need to record it!'" recalls Shelton. "And after it hit No. 1, he asked for it back," jokes Lambert, who took home a Grammy, a CMA and an ACM award for her recording. But Douglas agrees the song found the right home. "If a man sang it, there would be a creepy factor," he says. "Who wants a strange man knocking on your door?"

Lambert was wowed by the song the moment she heard it. "It was just so beautiful," she says.

"CHICKEN FRIED"
ZAC BROWN BAND

Sometimes all it takes to write a good song is time. For Wyatt Durrette, Zac Brown's longtime friend and writing partner, "Chicken Fried" was born 16 years ago. "Well before I met Zac, when I was 21, I wrote the chorus and the melody," says Durrette. But the song hadn't gone much further than that until he hooked up with Brown. The two were out one night at the Dixie Tavern in Marietta, Ga., where they had met years earlier. "It was late, they were closing up, and I was like, 'Hey, I've got this song' and started playing it to him," says Durrette. "Zac started picking around right away and was like, 'We've got to do something with that!'" Four years later they had a song they were proud of. "We slowly started making sense of all the things that were important to us," he says, "Friends, family, Southern cooking, a good pair of jeans." But the events of Sept. 11 made what really matters abundantly clear. "Zac wrote the patriotic verse right after 9/11," says Durette. "It was the last verse and the best one."

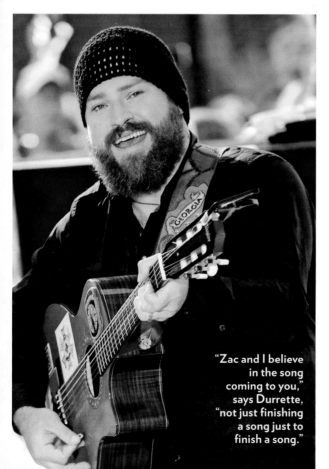

"Zac and I believe in the song coming to you," says Durrette, "not just finishing a song just to finish a song."

"It's one of those timeless messages," says Flatts' Jay DeMarcus of his hit with bandmates Gary LeVox (pictured) and Joe Don Rooney.

"MY WISH"
RASCAL FLATTS

It began as a challenge from songwriter Jeffrey Steele's then 13-year-old daughter Justine. "Justine was giving me grief about how I had written songs about my two other daughters, Casey and Jessie, but not about her. I said 'You know what? I'm going to write you a song today.' She had the typical teenager response: 'Yeah, right.'"

But in the studio that day, Steele and cowriter Steve Robson found the words "just started popping out," says Steele. "'I hope the days come easy and the moments pass slow . . .'" The pair cut a demo that day, and Rascal Flatts made it a No. 1 hit. "We knew immediately that it would touch so many different people in so many different seasons of their lives," says Jay DeMarcus. Justine was sold too. "At first she thought the song was corny because, you know, she's a hipster," says Steele with a laugh. "But she loves it now. She'll tell people, 'You know, my dad wrote that song for me.'"

BIG HITS FROM THE BIG SCREEN

These chart-toppers took their inspiration from the movies

▲ **"TIL SUMMER COMES AROUND"**
By Keith Urban: inspired by 1979's *The Warriors*
The abandoned theme park in the cult film inspired Urban's 2011 wisftful hit about lost love.

◄ **"YOU HAD ME FROM HELLO"**
By Kenny Chesney: inspired by 1996's *Jerry Maguire*
Chesney penned his 1999 No. 1 hit after hearing future wife Renée Zellweger say a similar line in the film.

▼ **"BLUE CLEAR SKY "**
By George Strait: inspired by 1994's *Forrest Gump*
Forrest's awkward phrasing ("Of course, it's backwards," says song cowriter Bob DiPiero. "It should be 'clear blue sky' ") inspired a No. 1 hit for Strait in 1996.

▲ **"YOU CAN'T TAKE THE HONKY TONK OUT OF THE GIRL"**
By Brooks & Dunn: inspired by 2002's *Sweet Home Alabama*
Songwriter Bob DiPiero called the movie "every kind of country cliché" but took that line from the film to make a 2004 country hit.

Swift scribbled the lyrics to "Love Story" on a piece of paper ripped from her journal.

"LOVE STORY"
TAYLOR SWIFT

If there's one pair of ears Swift can usually depend upon, it's those of her mom, Andrea. "My mom is usually a great gauge for whether a song will do well," she says. But sometimes even Mom gets it wrong. Take the singer's 2008 hit: "Nobody wanted me to record it. Nobody thought it was good." The hesitation may have come from the fact that the song (written in 20 minutes on her bedroom floor) was about a guy Swift had liked but who got the thumbs-down from her friends and family. "For the first time, I could relate to that Romeo-and-Juliet situation," she has said. Swift may have taken the romantic advice to heart (she never did date the guy), but luckily she listened to her own voice on the music and insisted on recording the tune. It's since sold more than 5 million copies. "I knew it could be magical," she says. "Sometimes you just have to champion your own songs."

"INDEPENDENCE DAY"
MARTINA McBRIDE

The one question everyone asks songwriter Gretchen Peters about the iconic hit she penned is if she's the little girl in the song. "No," she says, "it did not come from personal experience." But then she pauses. "That's not entirely true. Long after I had written the song, I realized I wrote a song about an 8-year-old girl whose world is completely blown apart, and that really describes my childhood at that age," she says. "My parents were in the middle of a divorce. It wasn't a situation of abuse, but my world was definitely spinning out of control." The song also struck a chord with McBride, who took it to No. 1 in 1994. "I had no hope anyone would record it because it was too dark a subject matter," says Peters. "It was incredibly gutsy for Martina to do."

"Martina was a new artist, but she stuck her neck out and believed in the song," says Peters, whose handwritten lyrics are on loan to the Country Music Hall of Fame.

"SMALL TOWN SOUTHERN MAN"

ALAN JACKSON

Though the title came long before the lyrics, Jackson had one certain small-town Southern man in mind when he penned this 2007 No. 1 hit: his dad, Eugene, who died in 2000. "I pulled from my memories of him because he fit that title," he says. "He was a very good man and a special person. He was just a hardworking man and didn't have many vices and gave all his time to his family. Sometimes you don't know how special that is until you are a grown man yourself." Among the memories: the family's house, which started as a 12 x 12 toolshed before his dad added on, and which inspired the line "Seven people livin' all together in a house built with his own hands." Jackson also drew from his last moments with his father for the line "Finally death came callin' for this small town Southern man/ He said it's alright 'cause I see angels and they got me by the hand." "We were all there at his deathbed singing hymns, and my sister told him, 'Daddy, Mama's all right. We're going to take care of her,'" Jackson recalls. "A minute later he went home." Real-life moments like those, he says, can inspire great songwriting: "You can make up a story and it can be good, but real experience makes a better song."

"My parents were just good people," the singer says of Ruth and Eugene Jackson.

"BEFORE HE CHEATS"

CARRIE UNDERWOOD

The *American Idol* winner may have taken the song to No. 1, but it was actually written with another singer in mind. "At the time, Gretchen Wilson had just had a huge hit with 'Redneck Woman,'" says songwriter Chris Tompkins. "She was kind of hot and edgy, so I was trying to think of something she could record." When the song, cowritten with Josh Kear, caught Underwood's attention instead, "we were super excited but a little surprised," says Tompkins. "She's a good girl; she's got the America's sweetheart thing about her." Not only was Underwood up for the challenge, "she wanted to do more to the guy!" he says. After he and Kear penned a new (angrier!) verse, though, Underwood decided the original was tough enough.

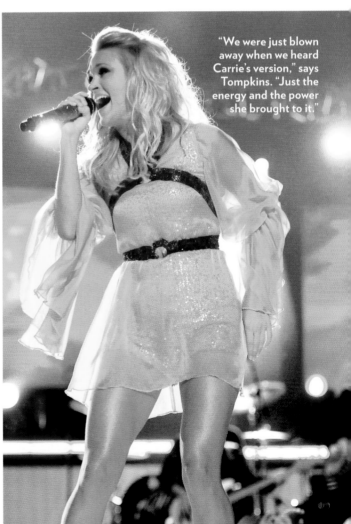

"We were just blown away when we heard Carrie's version," says Tompkins. "Just the energy and the power she brought to it."

When Country WASN'T

Sure, they're all on top of their game *now*, but when they were all just starting out in Nash these future superstars got talked into some seriously uncool photo shoots

BRAD PAISLEY
1999

KEITH URBAN
1992

REBA McENTIRE
1976

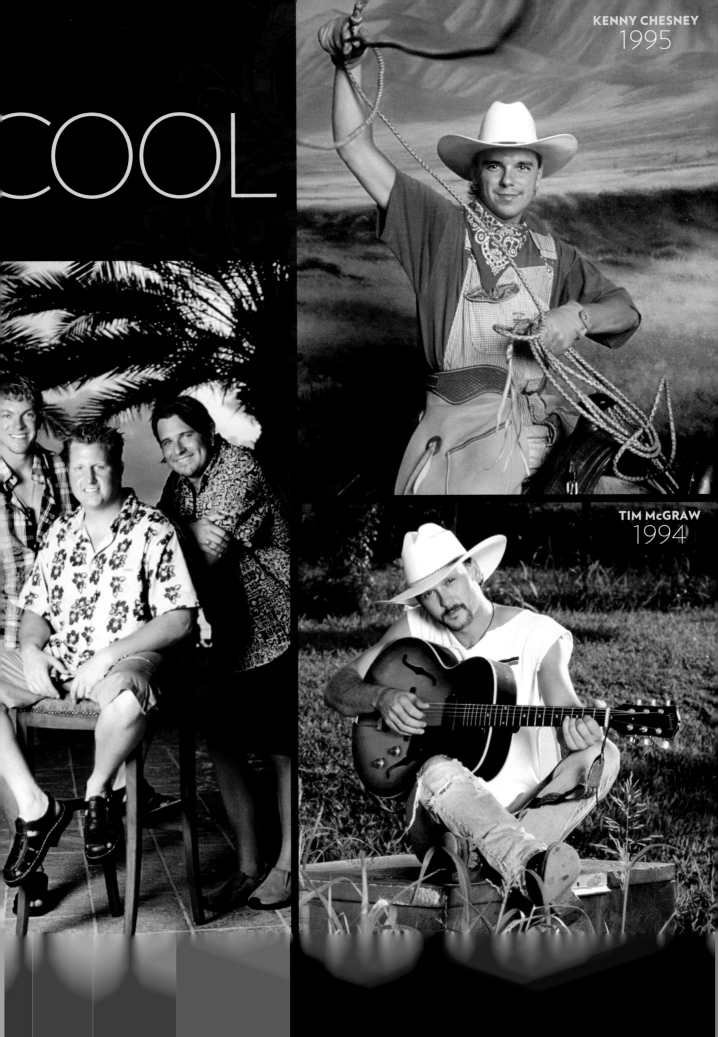

COOL

KENNY CHESNEY
1995

TIM McGRAW
1994

MASTHEAD

EDITOR | Cynthia Sanz **DESIGN DIRECTOR** | Andrea Dunham **ART DIRECTOR** | Cynthia Rhett **ART PRODUCTION DIRECTOR** | Georgine Panko **PHOTO DIRECTOR** | Chris Dougherty
MANAGING PHOTO EDITOR | Christine Ramage **ASSOCIATE PHOTO EDITOR** | Jen Lombardo **ASSOCIATE EDITORS** | Danielle Anderson, Eileen Finan **WRITERS** | Joey Bartolomeo, Alicia Dennis
Rennie Dyball, Mark Grey, Liza Hamm, Steve Helling, Julie Jordan, Melinda Newman, Thailan Pham, Michelle Tauber, Kay West **RESEARCH** | Paul Chi, Ivory Jeff Clinton, Deirdre Gallaghe
Mary Hart, Daniel Levy, Debra Lewis-Boothman, Hugh McCarten, Gail Nussbaum, Mary Shaughnessy **COPY** | Joanann Scali (Copy Chief), James Bradley (Deputy),
Aura Davies (Copy Coordinator), Ellen Adamson, Jennifer Broughel, Pearl Chen, Gabrielle Danchick, Valerie Georgoulakos, Lance Kaplan, Alan Levine, Jennifer Shotz (Copy Editors)
SCANNERS | Brien Foy, Stephen Pabarue **IMAGING** | Francis Fitzgerald (Imaging Director), Robert Roszkowski (Imaging Manager), Romeo Cifelli, Charles Guardino (Imaging Coordinator
Managers), Jeffrey Ingledue **SPECIAL THANKS TO** | Céline Wojtala (Director), David Barbee, Jane Bealer, Margery Frohlinger, Suzy Im, Ean Sheehy, Patrick Yang

TIME HOME ENTERTAINMENT: **PUBLISHER** | Richard Fraiman **GENERAL MANAGER** | Steven Sandonato **EXECUTIVE DIRECTOR, MARKETING SERVICES** | Carol Pittard **EXECUTIVE DIRECTOR,**
RETAIL & SPECIAL SALES | Tom Mifsud **EXECUTIVE DIRECTOR, NEW PRODUCT DEVELOPMENT** | Peter Harper **DIRECTOR, BOOKAZINE DEVELOPMENT & MARKETING** | Laura Adam
PUBLISHING DIRECTOR | Joy Butts **ASSISTANT GENERAL COUNSEL** | Helen Wan **BOOK PRODUCTION MANAGER** | Suzanne Janso **DESIGN & PREPRESS MANAGER** | Anne-Michelle Gallero
BRAND MANAGER | Michela Wilde **ASSOCIATE BRAND MANAGER** | Melissa Joy Kong **SPECIAL THANKS TO** | Christine Austin, Jeremy Biloon, Glenn Buonocore, Malati Chavali, Jim Childs,
Susan Chodakiewicz, Rose Cirrincione, Jacqueline Fitzgerald, Carrie Frazier Hertan, Christine Font, Lauren Hall, Malena Jones, Mona Li, Robert Marasco, Kimberly Marshall,
Amy Migliaccio, Nina Mistry, Dave Rozzelle, Ilene Schreider, Adriana Tierno, Alex Voznesenskiy, Jonathan White, Vanessa Wu

CREDITS

COVER | Clockwise from top left: Jeff Lipsky/CPI; Andrew Southam; Brian Doben; George Holz; Jeff Lipsky/CPI(3) **TITLE PAGE** | Shutterstock **CONTENTS** | Shutterstock; insets (from left): Matt Sayles/AP; Brian Doben; Roderick Trestrail II; Jeff Lipsky/CPI **THE KINGS OF THE ROAD** | Pages 4-5: Shutterstock; Insets (from left): Melanie Dunea/CPI; Jeff Lipsky/CPI; Brian Doben; **6-7:** Robb D. Cohen/Retna; **7-8:** Clockwise from top: Melanie Dunea/CPI; Jim Smeal/BEImages; Sipa; Courtesy KC; Lisa Rose/Globe; Splash News; **10-11:** Clockwise from right: Jeff Lipsky/CPI; Christopher Polk/Getty Images; Rick Diamond/Getty Images; Christopher Polk/Getty Images; **12-13:** Clockwise from left: Jeff Lipsky/CPI; News LTD/Newspix/Rex USA; John Elliot/Headpress/Retna(2); Francis Specker/CBS/Landov; **14-15:** Kevin Mazur/Wireimage; **16-17:** Clockwise from left: Marc Royce/Corbis Outline; Courtesy Brad Paisley; Mark Humphrey/AP; Larry Busacca/Wireimage; **18-19:** Jeff Lipsky/CPI; **20-21:** Clockwise from top left: Seth Poppel/Yearbook Library; Cliff Watts; Sony; Ralph Nelson/Warner

Bros.; John P. Johnson/Warner Bros.; Merrick Morton/Twentieth Centruy Fox; Everett Collection; **22-23:** Andrew Southam; **24-25:** Clockwise from left: Randi Radcliff/Admedia/Sipa; Dave Gatley/USO Photo; Photofest; Everett Collection; **26-27:** Clockwise from right: Brian Doben; Kika Press/Pacific Coast News; Moulin/Dalle/Startraks; Hussein Samir/Sipa; **28-29:** Clockwise from top: Robert Galbraith/Reuters; Christopher Polk/Getty Images; Mavrix; Graham Whitby Boot/Allstar/Globe; Melanie Dunea/CPI; Kevin Winter/Getty Images; Courtesy Taylor Swift **THE BIG VOICES** | **30-31:** Shutterstock; Insets (from left): Jeff Lipsky/CPI; George Holz/Universal Music; Brian Doben; **32-33:** Jeff Lipsky/CPI; **34-35:** Clockwise from left: Matt Sayles/AP; Courtesy Carrie Underwood; Ray Mikshaw/Fox; Christopher Polk/Getty Images; Chris Delmas/Visual Press; **36-37:** David McClister; **38-39:** Kristin Barlowe; **40-41:** Peter Yang/August; **42-43:** Cliff Watts/Icon Photo; **44-45:** Brian Doben; **46-47:** George Holz/Universal Music **THEIR LIFE IS A COUNTRY SONG** | **48-49:** Shutterstock; Insets (from left): Brian Doben; F. Ferrand/Faute-au-graphe; George Holz; **50-51:** Brian Doben; **52-53:**

Clockwise from left: George Holz; Courtesy Trace Adkins; Seth Poppel/Yearbook Library; Ron Galella/Wireimage; **54-55:** Peggy Sirota; **56-57:** Clockwise from right: Admedia/Wireimage; Central Image Agency/Filmmagic; Arlene Richie/Media Sources; Stephen d'Antal/Rex USA; F. Ferrand/Faute-au-graphe; **58-59:** Clockwise from left: George Holz; Courtesy Kellie Pickler(2); Joe Buissink; Ray Mickshaw/Wireimage **BEFORE THEY WERE STARS** | **60-61:** Seth Poppel/Yearbook Library(10); (Brown) Courtesy South Forsyth High School; (Chesney) Splash News; (Currington) Courtesy Effingham High School; **62-63:** Seth Poppel/Yearbook Library(20); (Young) Courtesy Oakland High School(2); (Jackson) Courtesy Alan Jackson; (Urban) Annette Dew/Newspix/News LTD **THE MODERN LEGENDS** | **64-65:** Shutterstock; Insets (from left): Terry Calonge; Brian Doben; Kurt Markus; **66-67:** Terry Calonge; **68-69:** Clockwise from left: Terry Calonge; Everett Collection; Glenn A. Baker/Shooting Star; Ron Galella/Wireimage(2); **70-71:** Dan Harr/Admedia; **72-73:** Clockwise from top: Stephen Albanese/Michael Ochs Archive/Getty Images; Lou Dematteis/Redux; Michael Caulfield/Wireimage; Courtesy

artist; Courtesy TIME; Time Life Pictures/DMI/Getty Images; Seth Poppel/Yearbook Library; **74-75:** Brian Doben; **76-77:** Clockwise from left: Lynn Goldsmith/Corbis; Courtesy Reba; Sara Krulwich/NYT/Redux; Courtesy Reba; The CW/Landov; Everett Collection; **78-79:** Michael Lavine; **80-81:** Clockwise from top left: Courtesy Ronnie Dunn; Curtis Hilbun/AFF; Alan Mayor; Courtesy Kix Brooks; Rick Diamond/Getty; **82-83:** Kurt Markus; **84-85:** Clockwise from top: Glenn A. Baker/Shooting Star; Jeff Lipsky/CPI; Bob Noble/Globe Photos; Courtesy Alan Jackson(2) **THE NEW GENERATION** | **86-87:** Shutterstock; Insets (from left): Brian Doben(2); Peter Yang/August; Brian Doben; **88-89:** Brian Doben; **90-91:** Brian Doben; **92-93:** From left: Brian Doben; Peter Yang/August; **94-95:** Andrew Southam/Warner Music; **96-97:** From left: Peter Yang/August; Anne Marie Hensley; **98-99:** Brian Doben; **100-101:** From left: Peter Yang/August; Kate Powers; **102-103:** Brian Doben **BREAKTHROUGHS** | **104-105:** Shutterstock; Insets (from left): Andrew Southam; Rande St. Nichols; Marc Morrison/Retna; **106-107:** From left: Marc Morrison/Retna; Roderick Trestrail II; **108-109:** Clockwise from left: Rande St. Nichols; Andrew

Southam; Brian Doben **BEHIND THE LYRICS** | **110-111:** Shutterstoc Insets from left: Jeff Lipsky; C. Flanigan/Filmmagic; Rebecca Letz/Sipa **112-113** From left: Alan Mayor; Rebecca Letz/Sipa; **114-115:** From left: Courtesy We: Virginia Film Office; Courtesy Bra Paisley; Christopher Polk/Getty Images; **116-117:** From left: Maric Anzuoni/Reuters; Beth Gwinn/Retna; Michael C. Hebert/New Orleans Saints; **118-119:** Jason Moore; **120-121:** C. Flanigan/Filmmagic; Kristin Callahan/Acepixs; Jason Moore; **122-123:** From left: Everett Collection(4); Rex USA; Paul Natkin/Wireimage **124-125:** From left: Tony Phipps; Jeff Lipsky/CPI; Kevin Mazur/Wireimage **WHEN COUNTRY WASN'T COOL** | **126-127:** From lef Morrison-Wulffratt/Retna; Micha Ochs Archive/Getty Images; John Elliott/Headpress/Retna; Marc Morrison/Shooting Star; Eddie Sanderson/Shooting Star; Marc Morrison/Retna **BACK COVE** 1st row (from left): Cliff Watts/Icon Photo; Terry Calonge; Matthew Rolston; Peter Yang/August; 2nd row (from left): Andrew Southam(2); Brian Doben; Peter Yang/August; 3rd row (from left): Brian Doben; Peter Yang/August; Kristin Barlowe; 4th row (from left Jae C. Hong/AP; Dana Tynan; Kur Markus; Melanie Dunea/CPI